variable capital

About the authors

David Campbell is Reader in Fine Art at the University of Ulster, Belfast.
Mark Durden is Professor of Photography at Newport School of Art, Media and Design, University of Wales.

Acknowledgments

the Bluecoat acknowledges funding received for its core activities and the exhibition Variable Capital from Arts Council England, Liverpool City Council and the Liverpool Culture Company.

David Campbell and Mark Durden would like to thank Bryan Biggs and Sara-Jayne Parsons at the Bluecoat, Robin Bloxsidge at Liverpool University Press, Stephen Heaton and Lisa Rostron at Lawn Creative, Sophie Wallace for image research, and all the galleries and artists who gave the permissions for reproductions.

David Campbell would like to thank the University of Ulster and the Arts Council of Northern Ireland for their support with this project, but especially Sue, Meg and Robbie.

Mark Durden would especially like to thank Lydia, Anna, Alexis and Nikolas.

This book is published by

Contents

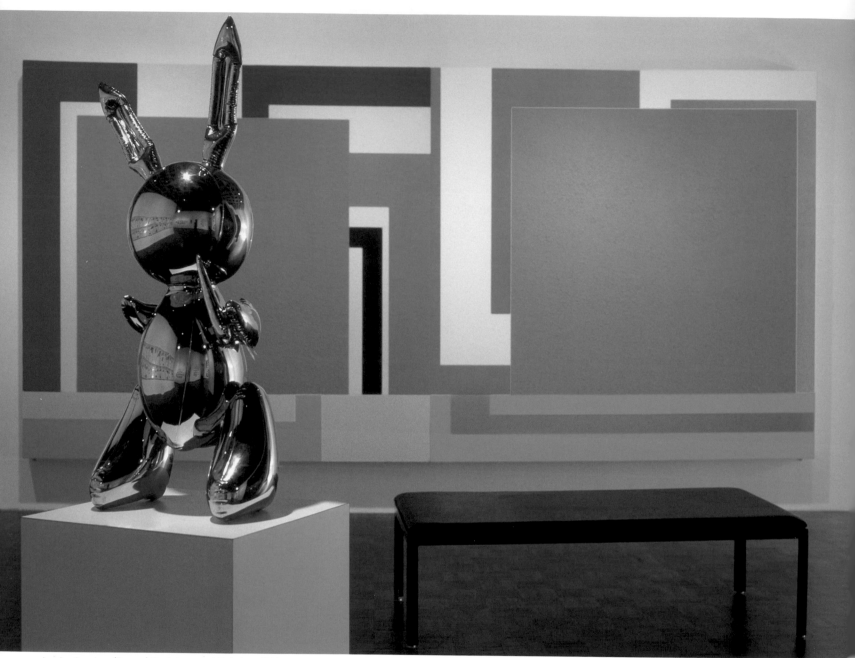

Louise Lawler, *(Bunny) Sculpture and Painting*, 1999.

Introduction

Artists' fascination with pop culture and commodity aesthetics has led to the development of some of the most significant and popular art of the last fifty years. While much of this art has concerned itself with the celebration of commodities as objects of desire, relatively little work has addressed the social relations sustaining such cultures of excess.

Variable Capital counters this trend by examining the work of artists who have explored both the seductive and destructive character of contemporary capitalism and whose art reflects the impact of commodity production on the sphere of culture.

Cultures of consumption dominate every aspect of contemporary life. Their emergence as the principal propelling and operating forces of society in the early part of the twentieth century is inextricably linked to the historical development of capitalism. As modern industrial societies successfully developed their capacity for mass production,

they were compelled to manage and generate mass consumption.

New industries of advertising, marketing and promotion emerged to ensure that the flow of consumption accelerated, stimulating demand for an ever-expanding quantity and range of commodities. Since the 1950s, advertising in the USA and Western Europe has played a pivotal role in realising this goal, effectively colonising the realm of human need and desire, to engineer the belief in consumers that happiness was achieved through the consumption of commodities. During the latter half of the twentieth century, the industrialised nations experienced a massive proliferation of images, soliciting commodities to such an extent that we have become a culture intoxicated by the circulation of images and appearances that routinely regulate desire through the consumption of signs grafted to commodities.[1]

Much of the art produced from the 1950s to the present day

carries the imprint of consumerism. For some, notably the artists associated with Abstract Expressionism and the critical writing of Clement Greenberg, the response was a retreat into the autonomy of art in the face of the corrupting influence of Kitsch; for others associated with Pop art and Neo-Geo, consumer culture was enthusiastically embraced. For still others, many of whom are featured in the exhibition *Variable Capital*,[2] the confrontation with commodity consumption has resulted in work that challenges the viewer with uncomfortable realities about their own power relationship as consumers.

Much of this work is characterised by a willingness to engage with awkward or unexpected social situations that frame the production or consumption of commodities. Often this is achieved through wry disruptions of the familiar, creating a critical edge by means of displacement or emphasising the ridiculous. In the main, the work featured in *Variable Capital* is not motivated by any redemptive

intent, but driven by a critical desire to manifest the often absurd and brutal logic of commodification.

In the field of critical theory, work undertaken by the Frankfurt School sought to understand the relationship between modern culture and the technologies of mass industrial production. Theodor Adorno and Max Horkheimer's seminal essay on 'The Culture Industry'[3] argued that the culture industries of advanced capitalist societies manufactured 'mass' or 'popular' culture to manipulate the needs and desire of citizens so as to distract them from recognising their own exploitation under capitalism and dissuade them from doing anything about it.

According to Adorno the essential characteristics of all 'mass' culture produced by the culture industry are repetition and standardisation. He illustrates this through a comparison between 'popular' and 'serious' music, but the same principle can be applied to contemporary forms of popular culture, whether they

[1] Advertising constructs the need for commodities by wrapping the commodity, which has a particular use-value, with an image that promises satisfaction, social status, desirable lifestyle etc. The image enhances and 'sells' the commodity not on the basis of just its efficacy, but on the desirability of what it represents. So a commodity can have different images or signs attached to it as a result of changing market needs or different advertising campaigns that shift the image of a product. For example a vacuum cleaner might have an image of sexiness attached to it for one campaign, but for another it might be presented as efficient, green and intelligent. The use-value of the vacuum remains the same; it is the image attached to it that has changed, hence the relationship of the graft, suggesting something connected but external and detachable.
[2] The exhibition at the Bluecoat, Liverpool in spring 2008, examines the work of a range of international artists including Edward Burtynsky, Common Culture, Alexander Gerdel, Richard Hughes, Melanie Jackson, Louise Lawler, Hans Op de Beeck, Wang Qingsong, Julian Rosefeldt, Santiago Sierra, Larry Sultan, Brian Ulrich and Andy Warhol.
[3] Max Horkheimer and Theodor W. Adorno, 'The Culture Industry' in *Dialectic of Enlightenment*, New York: Herder and Herder, 1972.

be the formulaic nature of soap operas or the predictability of 'cop' films.

Adorno argued that the key feature of popular music was its standardisation, the interchangeability and substitutability of parts. In contrast, serious music is considered a 'concrete totality', a dialectical relationship between organic parts whereby 'every detail derives its musical sense from the concrete totality of the piece.'[4] Any alteration of a single part would result in the destruction of the totality and the artwork. For Adorno the purpose of mass culture is to distract and to pacify: 'no independent thinking must be expected from the audiences', instead 'the product prescribes every reaction.'[5]

While the Frankfurt school has valuable things to say about the character and function of commodity consumption and culture in capitalist society, there are problems of balance in their discussion of how human needs are manipulated in the interests of capital. Wolfgang Fritz Haug's work on commodity aesthetics provides a valuable development and critique of Adorno's thesis, critically examining the conditions under which mass manipulation takes place.

As Haug remarks in the introduction to his *Critique of Commodity Aesthetics*, 'manipulation could only be effective if it "somehow" latched on to the "objective interests" of those being manipulated.'[6] Haug's assertion that '"The Masses" are being manipulated while pursuing their interests'[7] is important as it enables manipulation to be understood as a process able to 'speak the language of real needs even if it is as it were an alien expression of those needs which are now estranged and distorted beyond recognition.'[8] According to Haug, individuals consume products they don't really need through the efficacy of what he calls 'commodity aesthetics', a process of inducement that shapes the values, perceptions, and behaviour of individuals so as to integrate them into the lifestyles of consumer capitalism.

It is interesting to note his conjunction of 'commodity' with 'aesthetics', as it signifies his attempt to address the seductive and sensual properties of the commodity by examining why citizens become not only willing, but also enthusiastic consumers.

Haug uses the term 'commodity aesthetics' to refer to 'a beauty developed in the service of the realisation of exchange value, whereby commodities are designed to stimulate in the onlooker the desire to possess and the impulse to buy.'[9] For Haug, the desire to possess the commodity is triggered by its ability to sensually engage the consumer through the incorporation of aesthetics into the production, distribution, and marketing of commodities. Haug highlights the importance of image and appearance in the promotion of commodities, wooing consumers with the promise of 'use value' and the satisfaction of their needs. That this satisfaction can never be fully realised but is always deferred is of course the essential and contradictory nature of capitalism, one that ensures its continued survival as an economic system. Mass production requires mass consumption – ever-changing fashion, built-in obsolescence and the creation of desire for the 'latest model' all conspire to keep individuals on the consumption treadmill.

Jean Baudrillard's influential writing on consumer culture has charted a similar course to that taken by Haug. His analysis of 'sign value'[10] has helped develop an understanding of why individuals choose particular products, the nature of the actual gratifications they derive, and the social function of consumption.

Baudrillard's work builds on Thorstein Veblen's analysis of conspicuous consumption[11] to argue that individuals choose various commodities as signs of social prestige, status and desirability. Whereas Veblen's study of display was confined to the upper classes, Baudrillard argues that in advanced capitalist nations the entire society is organised around consumption and the

[4] Theodor Adorno, 'On Popular Music', *Studies in Philosophy and Social Sciences*, 1941, Vol. IX, No. 1, p. 19.
[5] Horkheimer and Adorno, *Dialectic of Enlightenment*, p. 137.
[6] Wolfgang Fritz Haug, *Critique of Commodity Aesthetics*, Cambridge: Polity Press, 1986, p. 6.
[7] Ibid., p. 6.
[8] Ibid., p. 6.
[9] Ibid., p. 8.
[10] Jean Baudrillard, *For a Critique of the Political Economy of the Sign*, St. Louis: Telos Press, 1975.
[11] Thorstein Veblen, *The Theory of the Leisure Class: An Economic Study of Institutions*, Harmondsworth: Penguin Classics, 1994.

display of commodities. As Douglas Kellner describes, Baudrillard argues, 'just as words take on meaning according to their position in a differential system of language, so sign values take on meaning according to their place in a differential system of prestige and status.'[12]

Commodities form a system of hierarchically organised products and services operating as signs that register one's standing within the system. According to Baudrillard, consumers develop an understanding of the specific codes and rules of consumption whereby particular brands of commodities, whether they are trainers, mobile phones or cars, signify relative standing in the hierarchy of consumption. Certain objects have more prestigious signification, are desired, and therefore provide greater social gratification. Assisted by the promotional resources of the mass media, the momentum of this consumption accelerates. Commodities proliferate, multiplying the quantity of signs and spectacles, which in

turn results in the proliferation of what Baudrillard calls sign-value.

From this moment on, according to Kellner, 'Baudrillard claims, commodities are not merely to be characterised by use-value and exchange value, as in Marx's theory of the commodity, but sign-value - the expression and mark of style, prestige, luxury, power, and so on - becomes an increasingly important part of the commodity and consumption.'[13] In opposition to the apologists of capitalism who claim that it simply gives people what they want, Baudrillard argues that such wants and desires are socially constructed by capitalism to ensure its own survival through managed forms of consumption.

The problem with Baudrillard's theory of sign value, however, is that it fails to account for any form of resistance to capitalism's social construction. In his attempt to chart the massive societal changes brought about by the impact of new technologies,

Baudrillard claims that we live in a new era — one in which media, cybernetic models, computerisation, knowledge and information systems have replaced industrial production and political economy as the organising principle of society. Kellner describes this situation as 'a shift from a society in which the *mode of production* is primary to a society in which the *code of production* becomes the primary social force.'[14]

Baudrillard does not define 'code' with any precision but equates the concept with a series of 'simulation models' and a move to what Kellner describes as 'a "*semiological idealism*", whereby signs and codes become primary constituents of social life. In this new situation a person's labour power, body, sexuality, unconscious, and so on are not primarily productive forces, but are seen to be "operational variables", "the code's chess pieces."'[15]

As Kellner observes, according to Baudrillard 'we live in a "hyperreality" of simulations in which images,

spectacles and the play of signs replace the logic of production and class conflict as key constituents of contemporary capitalist societies.'[16] Much of the art featured in *Variable Capital* can be understood as a response to such a situation. For the artists associated with Neo-Geo, Baudrillard's theories offered an accurate analysis of contemporary culture and provided theoretical succour for their art. For others, his account of the experience of commodity culture is woefully one-sided and fails, or chooses to ignore, issues of exploitation, resistance or the possibility of a future beyond the dominion of the commodity.

[12] Kellner, Douglas, "Jean Baudrillard", *The Stanford Encyclopedia of Philosophy (Spring 2007 Edition)*, Edward N. Zalta (ed.),
 http://plato.stanford.edu/archives/spr2007/entries/baudrillard/
[13] Ibid.,
[14] For a discussion of this see Douglas Kellner, *Jean Baudrillard, From Marxism to Postmodernism and Beyond*, Oxford: Polity Press, 1989, p. 61.
[15] Ibid., p. 62.
[16] Ibid., p. 62.

HOT MEALS TO TAKE AWAY

- CHIPS
- DORRO RICE
- SPRING ROLL
- CRISPY DUCK
- CRISPY CHICKEN WINGS
- BARBEQUE SAUCE
- MUSHROOMS
- FRIED ONION
- PRAWN CRACKERS

KEBABS

	Small	Large
DONNER KEBAB	Small £3.30	Large £3.70
LAMB KEBAB	Small £3.40	Large £3.70
SHISH KOFTEH KEBAB	Small £3.35	Large £3.50
CHEF KEBAB	Small £ .	Large £4.10
STEAK KEBAB	Small £3.50	Large £3.70
CHICKEN KEBAB	Small £3.50	Large £3.75
MIXED KEBAB		Large £4.55
VEGETARIAN KEBAB	Small £ .	Large £3.50

WELCOME

STEAK & KIDNEY PIE	1.05	FISH IN BREADCRUMBS	1.80 1.15
CHICKEN & MUSHROOM PIE	1.05	SCAMPI	1.45
MEAT & POTATO PIE	1.05	FISH CAKE	.95
CHEESE & ONION PIE	.90	DONNER MEAT IN BAP	.60
PASTIES	.90	DONNER MEAT IN TRAY	1.80
PUDDINGS	.90	DONNER MEAT & CHIPS	2.40
SCOTCH EGG	.75	DONNER KEBAB small	2.50
SAVALOYS	.50	DONNER KEBAB large	2.75
SMALL SAUSAGE	.50	SALAD KEBAB	.60
LARGE SAUSAGE	.60	PICKLED ONIONS 12 EGGS	.25

CHICKEN LEG	1.60
CHICKEN BREAST	1.75
TURKEY STICK	
BUTTERED BAP	
SPRING ROLL	.55 .90
PEAS & BEANS	.30 .55
CURRY	.30 .55
GRAVY	
CHEESE & ONION FRY	.25
PINEAPPLE FRITTERS	
POTATO FRITTERS	
BURGER IN BATTER	
BURGER IN BAP	
CHEESE BURGER IN BAP	

THANK YOU

CHIPS	0.90	CHICKEN & MUSHROOM PIE	0.80	FRITTERS	0.90
COD	1.50	CORNISH PASTIE	0.85	GRAVY	0.28
HADDOCK	1.50	MEAT & POTATO PIE		CURRY SAUCE	0.39
PLAICE	1.60	STEAK & KIDNEY PUDDING	1.45	BEANS	0.39
CHICKEN	1.30	CHEESE BURGER	1.25	MUSHY PEAS	0.39
CHICKEN NUGGETS	1.05	SEAFARER BURGER	1.35	BREAD & BUTTER	0.11
SCAMPI		CHICKEN BURGER		TRAYS & CUPS	0.03
SAVOURY PANCAKE ROLL	0.75	FISH CAKES (2)	0.50	LARGE FORKS	0.32
CURRY ROLL		SAUSAGES (2)	0.70	COFFEE	0.48
CHEESE & ONION PIE	0.85	BEEFBURGERS (2)	0.70	TEA	0.42
STEAK & KIDNEY PIE	0.80	BLACK PUDDING	0.70	CANS OF POP	0.42
				LARGE BOTTLES	1.00

Curries · Kebabs · Fried Rice Dishes · Pies

CURRY DISHES
- King Prawn Curry 3.55
- Prawn Curry 3.50
- Chicken Curry 3.50
- Beef Curry 3.50
- Mixed Meat Curry 3.40

FRIED RICE DISHES
- Special Fried Rice 2.00
- King Prawn Fried Rice 3.00
- Prawn Fried Rice 3.00
- Chicken Fried Rice 2.00
- Yung Chow Fried Rice 3.30
- Char Nai Fried Rice 3.00

GREEK DISHES
- Donner Kebab 3.00
- Donner Burger 2.50
- Donner & Chips 3.10
- Shish Kebab 3.30
- Chicken Kebab 3.30
- Mixed Kebab 1.30
- Afella 3.00
- Afella , Chips & Salad 3.30

ENGLISH DISHES
- Mixed Grill 4.00
- Minute Steak 3.00
- Liver Dinner 2.60
- Pie Dinner 2.60
- Sausage Dinner 2.50
- Chicken Burger 2.10
- Beef Burger 2.00
- Cheese Burger 2.00
- Meat Pie 1.00
- Steak Pie 1.00
- Sausage 0.60
- Scallops (5) 1.00

OMELETTE DISHES
- Prawn Omelette
- Chicken Omelette
- Spanish Omelette
- Bacon Omelette
- Mushroom Omelette
- King Prawn Omelette

Burgers
BEEF BURGER	1.70	DOUBLE BEEF BURGER	2.60
CHEESE BURGER	1.80	CHICKEN BURGER	1.90
DOUBLE CHEESE BURGER	2.80	FISH BURGER	1.90

Pizzas
CHEESE & TOMATO	3.00	TUNA & PRAWN	3.80
CHEESE & HAM	3.20	HAM & BACON	3.20
CHICKEN & HAM	3.20	SALAMI	3.40

Kebabs
PORK KEBAB	2.80	FISH KEBAB	2.80
LAMB KEBAB	2.80	SHISH KEBAB	3.00
CHICKEN KEBAB	2.80	MIXED MEAT KEBAB	3.60

PIZZAS

All Pizzas have Cheese & Tomato

	10"	13"
CHEESE & TOMATO	3.00	5.00
CHEESE, TOMATO & MUSHROOM	3.50	5.50
CHEESE, TOMATO & PEPPERS	3.50	5.50
HAM	3.50	5.50
BACON	3.50	5.50
CHICKEN	3.50	5.50
SALAMI	3.50	5.50

PASTAS etc.

SPAGHETTI	3.70
CANNELONI	3.70
LASAGNE	3.50
LASAGNE VEGETARIAN	3.70
TAGLIATELLI	3.00
CARBONARA	3.75
GARLIC BREAD	1.50
GARLIC POCKET	1.95

CURRIES

	KORMA	MADRAS							JALFREZI	BRIANI
CHICKEN	£3.70	£3.45				£3.70	£3.70	£3.90	£4.90	
MEAT	£3.70	£3.45		£3.75	£3.75	£3.70	£3.70	£3.90	£4.90	
PRAWN	£4.70	£4.70	£4.75	£4.85	£4.85	£4.85	£4.75	£4.85	£4.90	£5.90
KING PRAWN										
CHICKEN TIKKA	£4.20	£4.20		£4.20	£4.20	£4.20	£4.20	£4.40	£5.30	
LAMB TIKKA	£4.40	£4.40	£4.50	£4.40	£4.50	£4.50	£4.50	£4.50	£4.70	£5.30
VEGETABLE	£3.20		£3.20		£3.20		£3.20	£3.30	£3.90	

Variable Capital

Variable Capital[17] explores how the experience of everyday life in advanced capitalist societies has informed the work of contemporary and recent artists. Andy Warhol figures as the most historical inclusion. His blatant relation between art and business sets an important precedent for the embrace of consumerism and the market by the Neo-Geo artists.

Beginning with Neo-Geo art in New York, Variable Capital encompasses the global reach of capitalism through the work of artists responding to the effects of rampant consumerism on communities and environments across the world.

Variable Capital is structured around two responses to commodity culture. The first is concerned with a realist exposé of the everyday operation of consumerism, focusing on both the seductive allure of the commodity and the social relationships that sustain its production and consumption. Here artists directly address the compulsive and fetishistic nature of the commodity form and, through an engagement with individual workers or consumers, re-present the conditions of their exploitation, alienation and subjugation as something to be viewed as an art experience. The second response deals with the fall-out of consumerism, its excess and waste.

Here artists focus more on the material debris of the advanced consumer economies of the West, by exploring and re-using culturally devalued materials and objects.

Opposite – Common Culture, *Colour Menus Installation*, 2002.
Shopping – A Century of Art and Consumer Culture. The Tate Gallery, Liverpool.

[17] 'Variable capital' is a term used by Karl Marx to explain how value is produced in a commodity. According to Marx in *Capital*, 'constant capital' is the value of goods and materials required to produce a commodity, while variable capital is the wages paid for the production of a commodity. Marx introduced this distinction because it is only labour-power which creates new value. Variable capital describes that proportion of capital that is invested in wages, in the purchase of labour-power. Marx called this capital 'variable' because it is this proportion of capital, which, if it is used wisely may produce a new, surplus value in the course of the labour process, over and above the 'necessary labour time' which the worker needs to live and is paid in the form of wages. This investment is the only one that creates new value, because the worker is able to produce more than he needs in order to live.

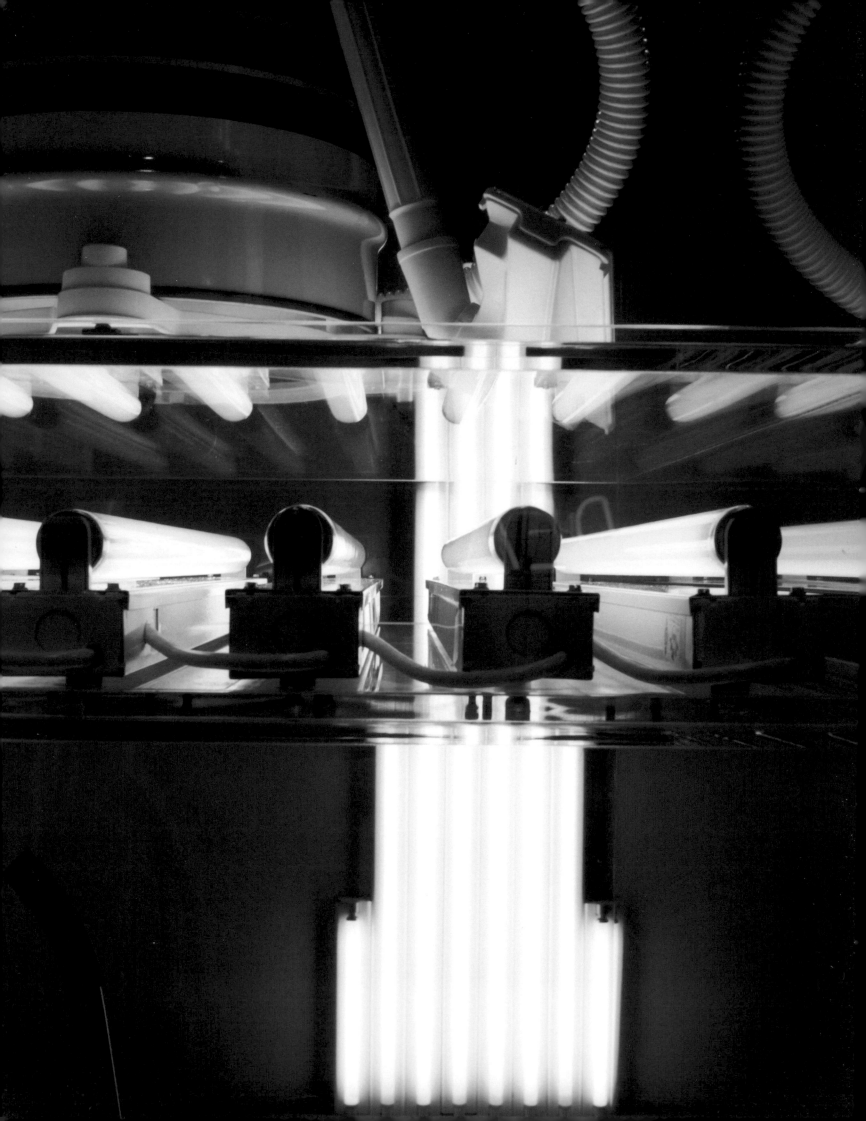

The New

In 1980 Jeff Koons caught the attention of shoppers passing the window of the New Museum of Contemporary Art in New York with a display of an illuminated light-box sign announcing *The New*. Accompanying the sign, Koons presented three fluorescent light-boxes, each containing a single Hoover appliance, a vacuum cleaner, rug-shampooer and shampoo polisher. So alluring was the display that the constant stream of shoppers entering the museum to purchase the appliances irritated the guards. *The New* was Koons' first solo exhibition.

He had earlier incorporated domestic appliances in his art in 1979, when in a series of works now titled 'The Pre-New', he bolted individual kitchen appliances — a coffee-pot, deep fryer, toaster etc. — to the front of fluorescent lighting units, effecting an abrupt juxtaposition. The work playfully trades on the art audience's tendency to read the presentation of any ordinary object as yet another ironic Duchampian gesture.

Such juxtapositions are often motivated by an attempt to explore the relationship between the serial mode of production embedded in the work of some Minimalist and Pop Art artists and that utilised in the production of everyday consumer goods. Koons' early work can be seen as a critical examination of modern forms of consumption, where the objective is not the fulfilment of the commodity's utilitarian intent, but rather the consumption of its sign value. After all, in the context of Koons' *Pre-New* sculpture, the deep fryer is not just a product with which to fry food, it is also an expression of lifestyle and status as well as a Pop Art quotation. Likewise, the fluorescent unit that accompanies it is never simply a light source but a mark of modernity and a reference to the Minimalist art of Dan Flavin.

In the sculpture exhibited in *The New*, Koons achieves the fusion of such variant applications in the marriage between the Hoover domestic products and the illuminated

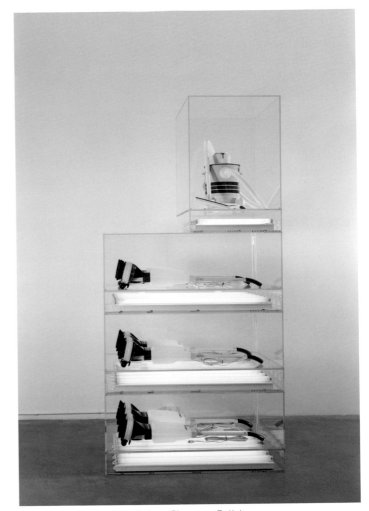

Jeff Koons, *New Hoover Deluxe Shampoo Polishers, New Shelton Wet/Dry 5-Gallon Displaced Quadra Decker*, 1981-1987.

Opposite – Louise Lawler, *Closer Than You Thought*, 2004/5.

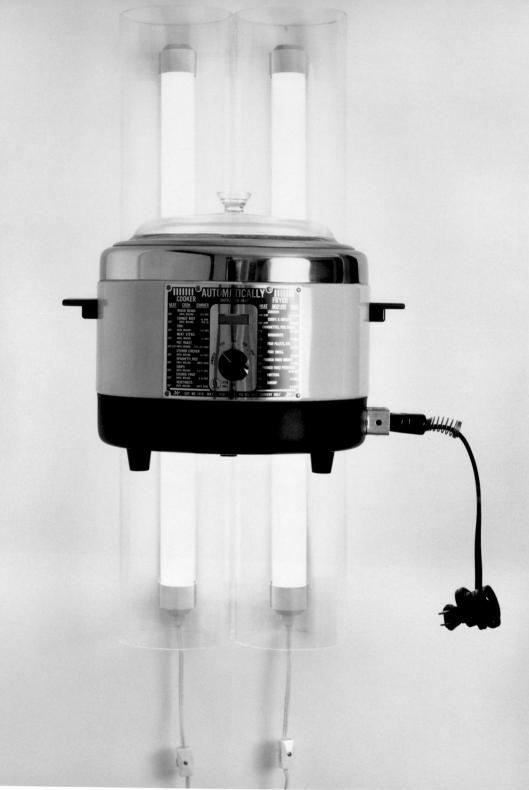

Jeff Koons, *Nelson Automatic Cooker/Deep Fryer*, 1979.

Minimalist structures in which they are displayed. The work emphasises the essential characteristic of the readymade, namely its ability to pose the question as to what quality an object must demonstrate in order for it to be defined as art. Koons' appropriation of the domestic appliance terminates any possibility of it ever realising its intended use value. Its incorporation into his sculpture literally showcases this, enabling the passage to its status as art, but it also demonstrates the importance of display to the operation of all commodities in a consumer culture.

Following Baudrillard, it could be argued that Koons is not so much interested in the specific utility of the appliances used in the sculpture exhibited in *The New* show, as in the fetishistic nature of their display and the conspicuous consumption of their sign value. The value of *the New Hoover Deluxe Shampoo polishers, New Shelton Wet/Dry 5-Gallon Displaced Quadradecker*, 1981-87, resides in the

opportunity it provides to elicit a differential marker of cultural sophistication. This spans from regular consumers able to appreciate the 'Hoovers' as quality domestic commodities, to those equipped with the cultural knowledge to recognise the display of the 'Hoovers' as a 'Koons' and thus an even more prestigious commodity: art.

Such sculptures represented the purest and most unadulterated appropriation of commodities by Koons. In later work, his use of readymade objects and images was usually mediated by their remaking in different material by commissioned craftsmen.

In 1985 Koons presented the exhibition *Equilibrium* at International with Monument Gallery. The show included a series of framed Nike posters featuring basketball players, the *Equilibrium* tank series of sculptures, incorporating varying numbers of basketballs suspended in aquariums, and a set of bronze casts featuring

aquatic lifesaving equipment – *Snorkel, Snorkel Vest, Aqualung* and *Life boat*. Clearly the choice of objects and images in the show are related, and the work could be read as symbolic of Koons' sensitivity to issues of balance and survival, given his precarious existence as an artist struggling to develop his career. The framed prints feature advertisements of various Nike-clad players who have been photographed posing with basketballs. The expression of the players to camera is quizzical, their balance of the basketball resonating with that achieved by Koons' suspension of identical balls in his tank works. Koons has indicated that the posters function as a cipher for achievement.[18] When one thinks about the essential physical dynamic of a basketball game, one thinks about speed, movement, balance and the aspirational momentum of the ball toward the hoop. Koons has drawn a parallel between the role art plays in the social mobility of white middle-class kids and that played by basketball for other ethnic groups.

[18] Quoted in 'Interview: Jeff Koons' by Anthony Haden-Guest in Angelika Muthesius and Benedikt Taschen, eds. *Jeff Koons*, Cologne: Taschen, 1992, p. 19.

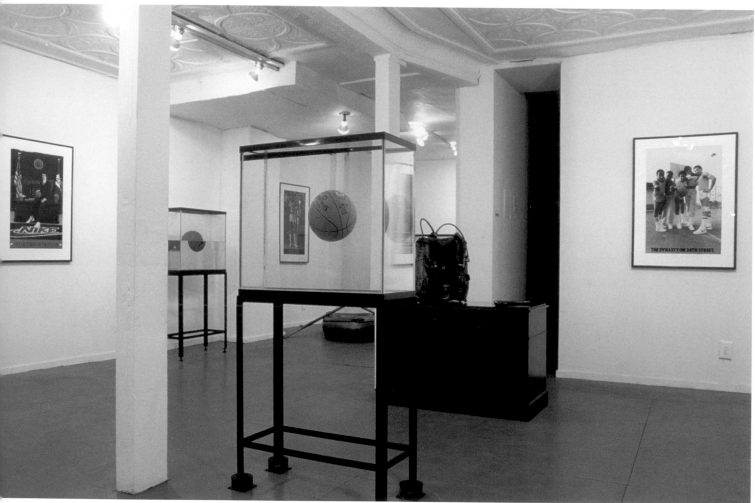

Jeff Koons, *Equilibrium, Installation*, International with Monument Gallery, New York, 1985.

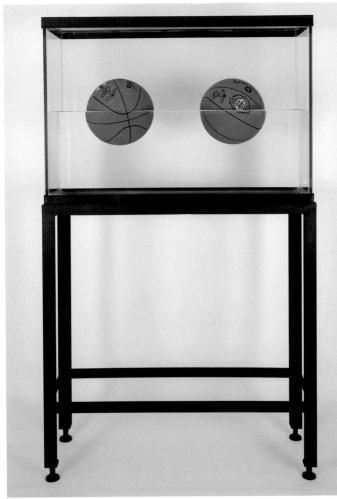

Jeff Koons, *Equilibrium*, Installation,
International with Monument Gallery, New York, 1985.

In terms of the relationship between the three types of work in the show (the 'trinity' as Koons describes them), the Nike posters seem to function as the upper coordinate on a graph of social mobility, while the *Equilibrium* tanks present a visual demonstration of their title, achieving a form of balance, however temporarily. The cast bronze lifesaving objects deaden the dynamic, with the paradoxical use of the heavy bronze sinking any illusion of buoyancy and safety. Koons was keen to downplay any parallel of this interpretation to his own set of circumstances, as someone struggling to keep his own artistic head above water.[19] Most of the work in the exhibition sold, but the expense of casting the bronze pieces meant that Koons lost between $12,000 and $14,000 on each of the large bronze sculptures. Had it not been for the fact that Koons could buttress this cost with money earned from his job as a Wall Street commodity broker, the viability of his survival as an artist might have been in doubt. However, the speculative risk Koons took in making the work paid off; the show attracted critical attention and the financial support of Los Angeles art dealer Daniel Weinberg.

[19] Ibid. p. 19. Asked if he thought the whole of the *Equilibrium* show could be read in terms of his inner turbulence, Koons replied, 'I don't think so. Perhaps a little bit. But I don't have much confidence in the subjective. I believe my art functions in the objective realm.'

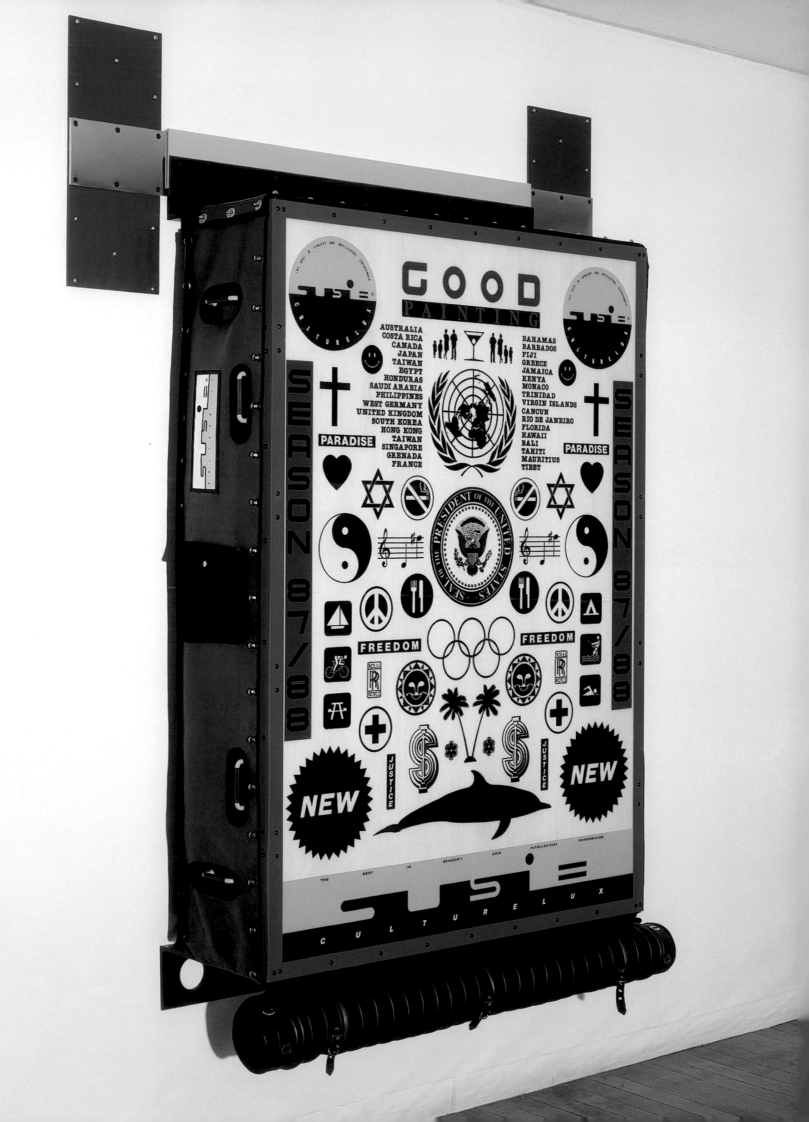

Branding

At the beginning of the 1980s, the New York art market was booming; the American economy was expanding, fuelled in part by Ronald Reagan's 1981 tax cuts. The recent 'return' of painting had been welcomed by a relieved art market, deflated by years of trying to market conceptually-orientated artwork, uncomfortable with its own status as a commodity. The bombastic display of heroic individualism, typified by the paintings of Julian Schnabel, seemed perfectly in tune with the zeitgeist of Reagan's America. However, by the mid-1980s, with a strong demand established for contemporary art, sections of the New York art market became restless with Neo-Expressionist painting and receptive to the work of younger artists whose appropriation of signs purloined from consumer culture also seemed to match the mood of the time. This work has been variously labelled Neo-Pop, Neo-Conceptualism, Simulationism and Commodity Sculpture, but is perhaps best known as Neo-Geo.

The term Neo-Geo usually applies to the work of a group of young artists closely associated with the International with Monument Gallery in New York's East Village.[20] Their collective marketing under the Neo-Geo label did not signal a shared artistic programme and, apart from the inflated sales pitch that accompanied the exhibition and discussion of their work, no group manifesto ever existed.

More than anything, the identification of work as Neo-Geo can be understood as an act of branding, a mechanism to harmonise the promotion and commercial exploitation of a range of art products that had distinct qualities, but could nonetheless be packaged in such a way as to highlight the shared similarities of the individual artists and establish and expand consumer demand for the art.

Neo-Geo involved relatively young artists. Apart from Haim Steinbach, who was about ten years older than the rest, all were in their late twenties and early thirties when Neo-Geo

was presented as the cool antidote to Neo-Expressionism. Most of the work appropriated readymade images and objects from America's consumer culture, taking its cue from media-savvy artists like Sherrie Levine, Louise Lawler and Richard Prince, to explore the readymade's potential to critique notions of authenticity and originality.

If Neo-Geo can be said to have a 'launch event' it has to be the occasion of the group show of Jeff Koons, Peter Halley, Ashley Bickerton and Meyer Vaisman, at the Sonnabend Gallery, New York in the autumn of 1986. Dan Cameron described the event as 'perhaps the most talked-about gallery show of the decade.'[21] The show attracted one of the biggest audiences in the gallery's history and quickly sold out with collectors from the United States, Europe and South America paying relatively high prices for work by relatively little known artists.

One of the earliest collectors of Ashley Bickerton's work was securities trader, Michael Schwartz, and for him the

potential Neo-Geo offered was clear: 'Neo-Expressionism was all the rage. Yet here was something very undiscovered and very exciting, and I could be at the center of it.'[22] As Bickerton confirmed, 'It was really the collectors' moment. The machine had been put in place by the neo-exers and was grinding along at full tilt by the time we got there in the late '80s.'[23] It is appropriate that an art so fixated with its own status as a commodity should be so appealing to a group of collectors, many of whose wealth was derived from the booming commodity markets of Reagan's America. As Jeffrey Deitch, then an art advisor to Citibank clients, put it: 'The role of key collectors in putting this together as a package, of identifying it as a recognisable new aesthetic, was crucial.'[24]

The fact that the constellation of artists associated with International with Monument had no agreed agenda, other than the shared platform of the gallery, indicates that the branding of the new art was always going to be imprecise.

Opposite – Ashley Bickerton, *Good Painting*, 1988.

[20] The emergence, in the early 1980s, of a number of artist-run galleries in New York's East Village proved to be fundamental to the development of Neo-Geo. Though modest in size, such galleries as Nature Morte, and later, International with Monument, played a crucial role in bridging the work of younger conceptually-orientated artists with the work of artists associated with more established galleries like Metro Pictures and the Sonnabend Gallery.
[21] Dan Cameron, International with Monument. *Artforum International* v. 38 no. 2 (October 1999) p. 127-8.
[22] Eleanor Heartney, 'The Hot New Cool Art — *Simulationism*', *Art News* v. 86, January 1987, pp. 130-37.
[23] 'Ashley Bickerton talks to Steve Lafreniere – 80s Then – Interview', *Artforum*, March 2003.
[24] Heartney, 'The Hot New Cool Art'.

Even the description of the 1986 Sonnabend exhibition as a 'Group Show' suggests that the nomenclature to describe the range of work on exhibition was underdeveloped, perhaps indicating a hesitancy as to what the artists had in common. Certainly Ashley Bickerton states as much — when asked if the four artists included in the show had come up with the idea of being shown together, he replied 'No. It didn't even have to be the four of us, it just turned out that way. That package was the result of quite a bit of maneuvering.'[25]

Descriptions of Neo-Geo art are wide-ranging, reflecting the varied nature of the work itself and the ideological stance taken towards it by individual commentators. Broadly speaking, Neo-Geo can be classified as having two main strands, an image-based practice utilising the history and medium of painting, represented principally by the work of Peter Halley and Ashley Bickerton, and the work of Jeff Koons and Haim Steinbach that centred upon the use and display of consumer objects. Both types of work share a common interest in the use of appropriation, primarily through the model of the readymade, and a fascination with the mass media and commodity consumption.

[25] 'Ashley Bickerton talks to Steve Lafreniere'.

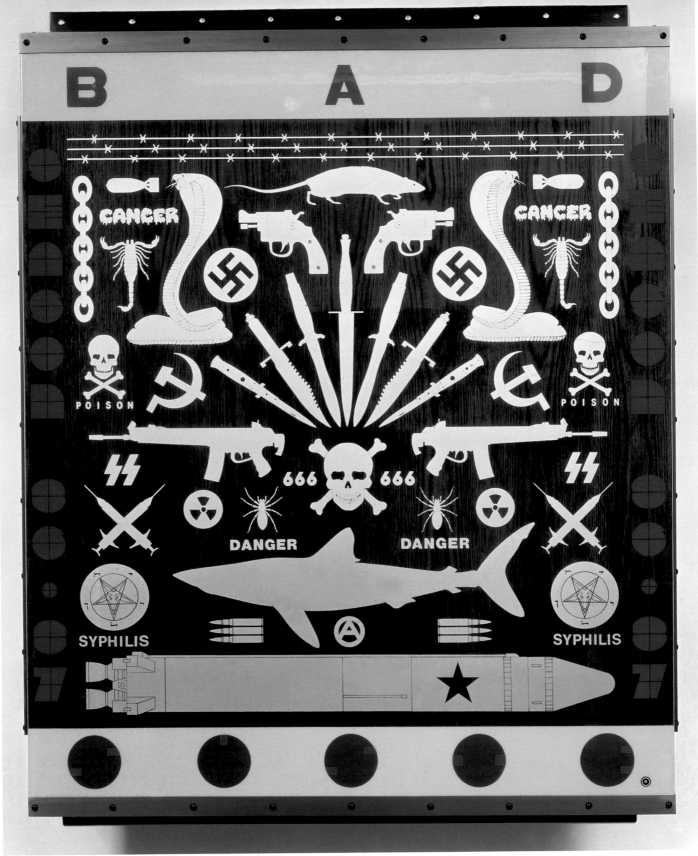

Ashley Bickerton, *Abstract Painting for People #4 (Bad)*, 1987.

Peter Halley, *Blue Cell with Triple Conduit*, 1986.

New Geometry

Peter Halley's work looks like a certain type of geometric painting, but in fact it can be seen as yet another act of appropriation. It treats the tradition of Modernist painterly abstraction as another kind of readymade, re-deploying its flat forms and geometric compositions in order to perform a diagrammatic function. Halley's use of geometric painting signals the loss of its ideals of 'stability, order and proportion'. He paints after what he refers to as the discrediting of the formalist project in geometry: 'It no longer seems possible to explore form as form (in the shape of geometry), as it did to the Constructivists and Neo-Plasticists, nor to empty form of its signifying function, as the Minimalists proposed.'[26] Geometry, for Halley, signifies neither transcendent order nor gestalt. Drawing upon Michel Foucault's *Discipline and Punish* 1975, Halley links geometry with systems of control and supervision. In paintings such as *Blue Cell with Triple Conduit* 1986, he attempts to provide a visual image of the complex, networked, social systems in which we are all caught. In *Prison with Yellow Background* 1984, a straightforward geometric composition rendered in black and day-glo yellow paint uses the style of the exalted tradition of geometric abstraction to present us with a graphically simplistic depiction of imprisonment. Such a painting becomes emblematic and functions akin to a sign. The structure of the prison makes an explicit reference to the incarcerating effects of the new systems and structures that determine our experience of contemporary culture. The day-glo colour can be seen to allude to the video game or the neon, gaudy displays of capitalist culture. Such phoney colour signals a decisive break from the spiritual, metaphysical and emotive investments in colour often underpinning Modernist abstract painting.

[26] The quotes are taken from Halley's essay, 'The Crisis in Geometry', published in *Arts Magazine*, New York, Vol. 58, No. 10, June 1984. This and all subsequent essays cited are available on his website: www.peterhalley.com/

Halley locates his practice against that of the Minimalists, artists who often cite industrial experience as formative to their work. For the Minimalists, seriality and centrality were strategies of composition that were linked with the material production of industry.[27] Halley says his generation of artists instead draws from the post-industrial experience of consumption and, citing Baudrillard, the 'hyperreal' world of highways, computers and electronic entertainment. Halley's new geometric painting alludes to the groundless and immaterial spaces of the new technologies of mediation and control. This is what is abstract in his paintings. Modernist Hard-Edge and Colour-Field painting styles are re-used in paintings bereft of mysticism and any adulatory relationship to geometry. For Halley, 'metaphysics is now the endless circulation of signs through the chutes of an unreal mental space.'[28] Against Modernism's utopian investment in the geometric form, Halley's abstract dizzying world of endless models and diagrams signals, as he puts it, 'a site of alienation and banality.'[29]

[27] Ibid.
[28] 'Essence and Model', published in *Peter Halley: Collected Essays 1981-1987*, Zurich: Edition Bruno Bischofberger Gallery, 1988.
[29] 'Notes on Abstraction', published in *Arts Magazine*, New York, Vol. 61, June/Summer 1987.

Peter Halley, *Prison with Yellow Background*, 1984.

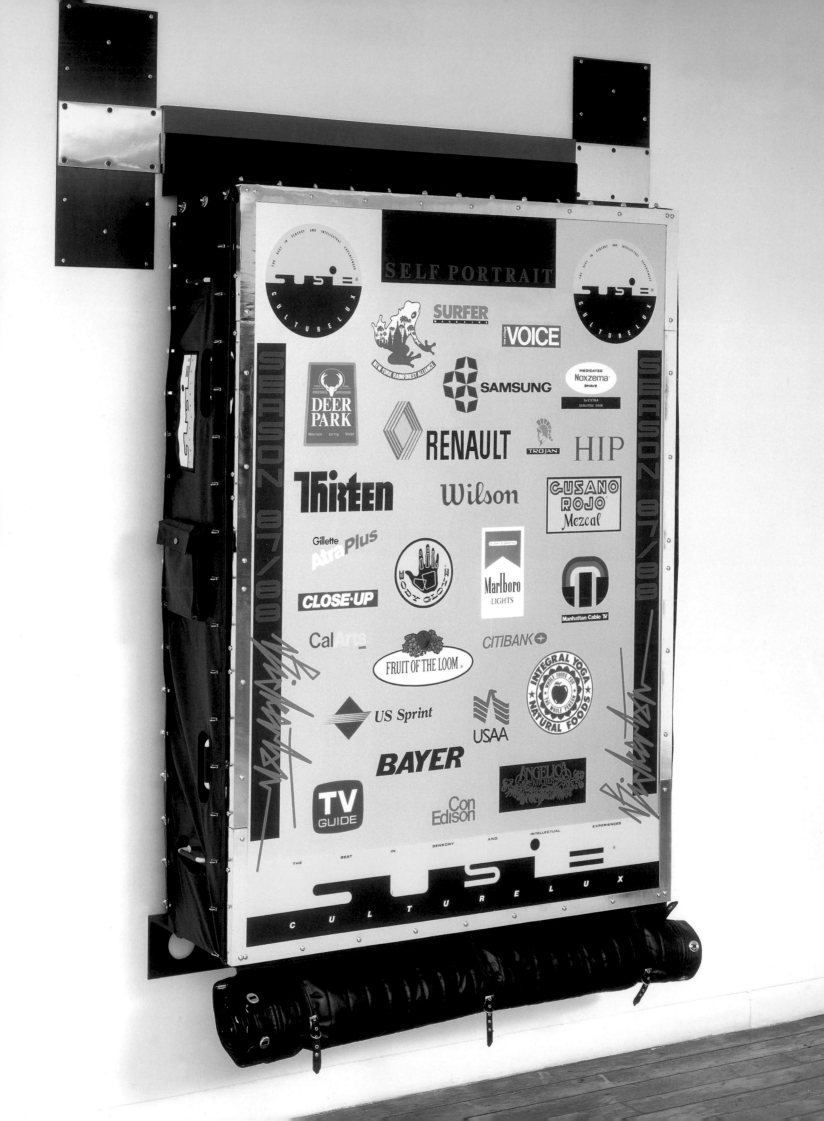

Logos

The work of Ashley Bickerton typifies Neo-Geo's scepticism toward art as a site of truth, authentic experience and original expression. His slickly fashioned objects are emblazoned with highly stylised logos that bring to mind a range of graphic sources from corporate signage to album cover design and sci-fi iconography. His use of signs is a witty illustration of Baudrillard's thesis that it is sign value, not the object, that dominates in consumer culture.

Bickerton hand-paints logos in systematic formations as if compiling a visual inventory or illustrating a comprehensive product range. The effect is to present a collection of images that seem to offer viewers a catalogue of visual possibilities that challenges them to discriminate between the signs and recognise their significance.

Despite the fact that the paintings are often given literal depth, by being either lifted off the supporting wall by means of industrial brackets or rendered on the front of fabricated metal boxes,

Bickerton is fascinated by the superficial. His industrial structures are swamped by a veneer of generic signs, lifted from the flood of logos circulating in consumer societies.

Sometimes he toys with the notion of authentic expression, amassing corporate logos to ask whether the products an individual consumes can signify an identity as in *Tormented Self-Portrait (Susie at Arles)*, 1988. Human and expressive values are represented by relationships between signs. Moral distinctions are like consumer choices, just different configurations of different signs, *Abstract Painting for People #4 (Bad)*, 1987 and *Good Painting* 1988. Bickerton teases the viewer, testing their consumer skill to identify the different signs, while suggesting that within consumerism, individual identity might amount to nothing more than the accumulation of stock signs. He seems particularly aware of his own identity as an artist in this process, highlighting the commodity status of his

own art objects, incorporating fittings and forms of construction that makes them mobile and user friendly. He draws attention to art's status as a cultural product circulating amid a luxurious sign system, caught in an international distribution network, continuously being stored, transported and promoted.

Opposite – Ashley Bickerton, *Tormented Self-Portrait (Susie at Arles)*. 1988.

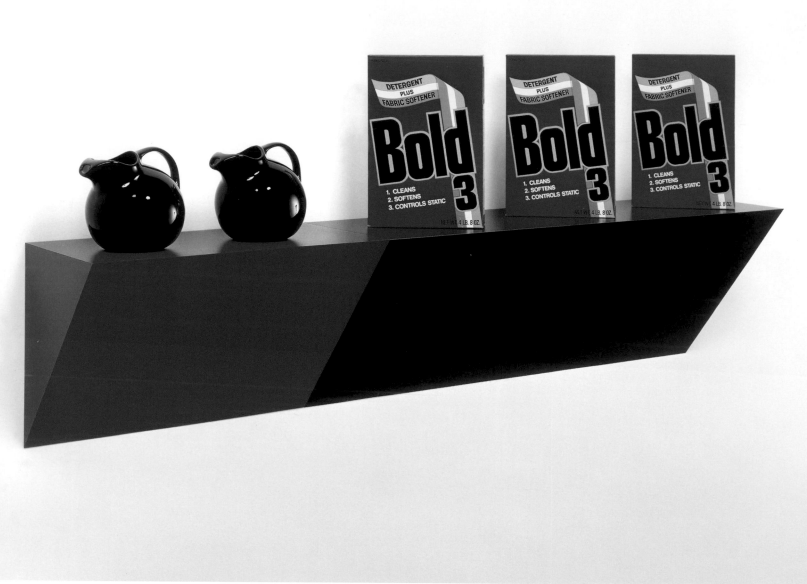

Haim Steinbach, *Supremely Black*, 1985.

Vanitas

Haim Steinbach was not included in the Sonnabend group show, but was acknowledged as a central figure of the Neo-Geo grouping.[30] His work is thoroughly immersed in the culture of commodity consumption. His signature style involves the ornamentation of sleek, Donald Judd-like Minimalist sculptural forms by the serial arrangement of shop-bought products. His artwork offers an awkward collision between familiar consumer goods, (lava lamps, digital alarm clocks etc.) and the custom-made, Formica-clad, Minimalist forms on which they rest. The veneer of the supporting form, transformed into a surface for display, can be interpreted both as a plinth upon which esteemed objects might be presented, or more convincingly, as a shelf, on which less illustrious products are sold or stored: *Ultra Red 2*, 1986.

The interplay between the arranged objects and the supporting structure suggests that Steinbach, like Koons, is interested not only in the status of commodities, including that of art itself, but the process by which they attain value through the conditions of their display.

Steinbach's work, manifest in the form of wall-based sculpture, rehearses a type of cultural restlessness that encourages the viewer to shuffle conceptually between an identification of the Minimalist structure as a privileged marker of high art, and a recognition of its corruption and subjugation as a mere utilitarian shelf on which vernacular objects are displayed. It could be argued that such an identification, encapsulating the cliché of the supposed battle between high and low culture, is itself just another readymade, available to be appropriated and deployed, along with the lava lamps and the packets of washing powder: *Supremely Black*, 1985.

There is something odd about Steinbach's consumer still life as the collection of objects appear out of place, both with each other and their new environment. There seems to be no sense to the relationship between objects, possessing neither the logic of the department store shelf nor the history of a personal collection of souvenirs. One might suspect that Steinbach is mesmerised by the ceaseless parade of fetishised commodities, transfixed by their familiarity and strangeness, dazzled by their forms and alluring surfaces, but in the end, it is his fascination with the process of consumption that is most telling. Paradoxically, his work seems to be less concerned with individual objects or groups of objects than with the demonstration that any object, be it an elephant's skull or a pair of Air Jordans, can be displayed and have equal value as a commodity. This seems to neutralise the principle of sign value, suggesting that Steinbach's displays do not provoke any process of evaluation to differentiate the relative value and status of the objects displayed within the frame of the sculpture; they are all deemed to be equal, and all difference evaporates. Steinbach is keen to highlight the futility of making value judgments, either about shop-bought commodities or the relative merit of his individual sculptures. He seems to suggest that in the end it comes down to the personal choice of the spectator, or more appropriately, the shopper.[31] Steinbach's insistence that value judgments are futile results in a situation in which all commodities are ascribed equal value, and hence no value. If this is the case, the much-vaunted 'freedom of choice' of consumerism is exposed as an empty, ideological gesture.

In the panel discussion moderated by Peter Nagy at the Pat Hearn Gallery on May 2 1986, Steinbach set out to differentiate his work from the appropriation artists associated with the Metro Pictures Gallery.[32] For Steinbach, these artists questioned the position of the subject in relation to the image/object, but for the Neo-Geo artists this had altered. He went on to describe the nature of the change: 'there is a renewed interest in locating

[30] Certainly Steinbach's position within the emerging new art was recognised by his inclusion on a panel discussion that attempted to map out some of the characteristics of the new art and which pre-dated the Sonnabend group show. Quoted in David Robbins, ed., 'From Criticism to Complicity', transcript of a panel discussion moderated by Peter Nagy at Pat Hearn Gallery, May 2, 1986, *Flash Art*, Summer 1986, p. 46.

[31] Ibid., p. 47. Haim Steinbach: 'The anxiety of late Capitalist culture is in use: in the futility we experience in value systems when faced with our reality; in the futility we find in moralising as a way of determining what's good or bad. Is there such a thing as a consumer object, a fetish object, an art object, or is it our relation to it that concerns us?'

[32] Artists such as Sherrie Levine and Richard Prince.

one's desire, by which I mean one's own taking pleasure in objects and commodities, which includes what we call works of art. There is a stronger sense of being complicit with the production of desire, what we traditionally call beautiful seductive objects, than being positioned somewhere outside of it. In this sense the idea of criticality is also changing.'[33] Steinbach's sculpture presents the viewer with a model for the unfulfilling space of consumption — a space destined to maintain its own survival through the endless stimulation of desire for commodities, and the commodity's unfailing ability to leave the consumer unsatisfied. Despite Steinbach's sculptures appearing to demonstrate the vivid plenitude of advanced consumer cultures, their ever-changing display of novel commodities could be understood as a flamboyant reiteration of the seductive obsolescence and emptiness at the core of consumption. This emptiness was also reflected by the Neo-Geo artists' apparent willingness to accept the inevitability of capitalism, abdicating them from any concept of politics that could or should contest existing power relationships. As Halley declared in 1986 'I think it's difficult nowadays to talk about a political situation: along with reality, politics is sort of an outdated notion.'[34]

Any claim that art might offer any transcendental, transgressive or critical potential was also considered delusory and old-fashioned. In their place the Neo-Geo artists offered the abdication of any critical responsibility: as Halley stated, 'More and more I try to stop judging and just observe.'[35] And in a similar vein, Meyer Vaisman declared 'I don't feel it is the responsibility of an artist to judge whether a culture is good or evil.'[36]

[33] Ibid., p. 46.
[34] Ibid., p. 47.
[35] Peter Halley interviewed by Michele Cone, *Flash Art*, February – March 1986, p. 37.
[36] Claudia Hart, 'Intuitive Sensitivity: an Interview with Peter Halley and Meyer Vaisman', *Artscribe*, Nov-Dec 1987, pp. 36-39.

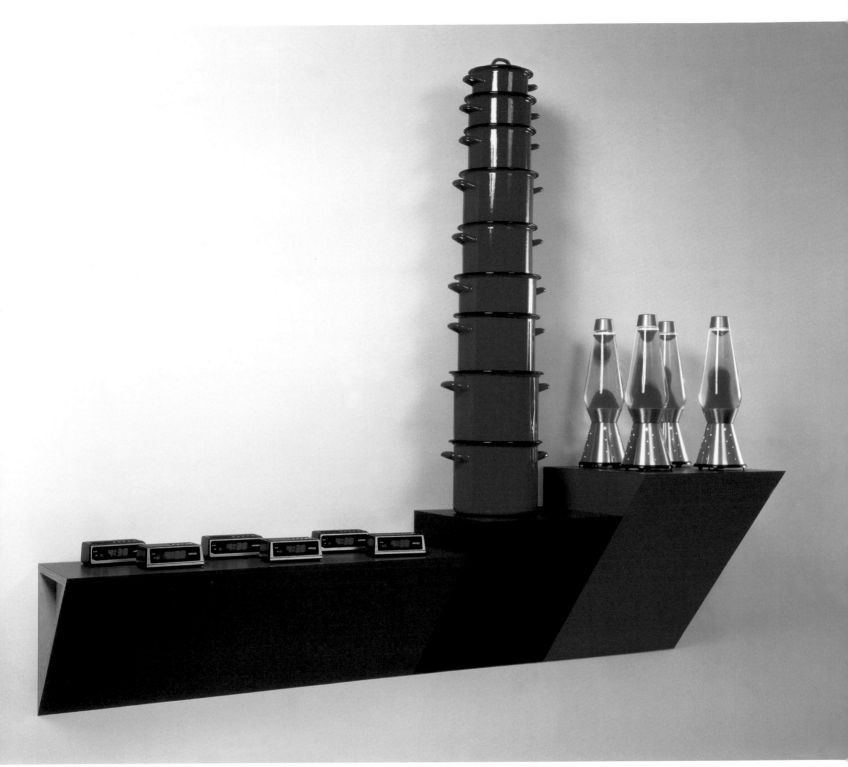

Haim Steinbach, *Ultra Red 2*, 1986.

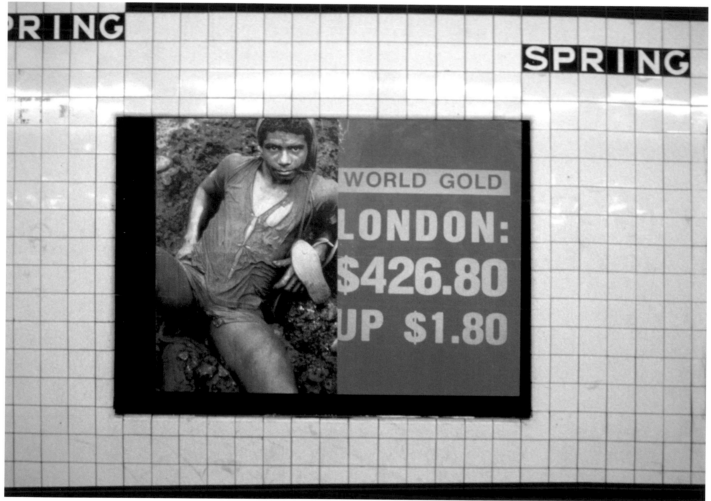

Alfredo Jaar, *Rushes*, 1986.

Gold

Left to the commodity market of the 1980s, Neo-Geo's acquiescence was richly rewarded. In marked contrast to their willing embrace of commodity fetishism, the Chilean artist Alfredo Jaar restages and repositions documentary photographs of social injustices and economic inequities. Here we are presented with images of those normally severed from the promotional babble accompanying commodities and their consumption, the workers. The images of the faces and bodies of workers and refugees are meant to serve as indictments of the West's consumerist binge. Jaar's use of the photographic document is underpinned by a belief in its affective dimension, its capacity to move the viewer from indifference to engagement and action. Photography as a realist medium is used to petition the viewer.

In one of his first major works, *Rushes*, 1986, made in New York soon after his arrival from Chile, Jaar located specific documentary images of the bodies of labourers in the heart of the city's trading centre.[37] He photographed the desperate and crude mining conditions in the Serra Pelada in the Brazilian Amazon, where hundreds of thousands of prospectors had settled since the late 1970s, when a huge deposit of gold was discovered in the area. In contrast to the photojournalism of Sebastião Salgado, which also made this event public, it is how Jaar staged his images that was significant. Pictures showing the muddied bodies and faces of these miners were displayed in place of ads in the Spring subway station near Wall Street, together with colourful posters indicating the current market prices of gold in London, New York, Tokyo and other world markets.

Behind such work lies a faith in the disruptive potential of realist documentary photography. Evidence of a desperate and primitive hunt for gold in the developing world was brought to the very centre of global power.

The focus on gold as the supreme commodity trades on the material's function as primarily a store of value, against which the value of all other commodities can be set. The location of Jaar's images, adjacent to Wall Street, the main commodity market in the western world, was a deliberate attempt to stage a collision between the agents of capitalist exploitation, the brokers of Wall Street, and images of the exploited miners of the Serra Pelada. One wonders what kind of revelation Jaar expected from this encounter? It seems driven by an appeal to conscience, a sincere belief that to make apparent the relation of exploitation would induce something approaching a moment of realisation or even a sense of guilt in those at the brain of the capitalist beast. Unfortunately, such a belief relies on the possibility that such conditions of exploitation were not already well known to the brokers of Wall Street, and rather than elicit their guilt, this knowledge might actually generate a perverse satisfaction.

In another version of this work, Jaar's installation *Out of Balance*, 1989, the faces and bodies of these miners were placed at the edge of long white rectangular light boxes, their landscape settings erased. The whole positioning and orchestration of this display, all above or below eye-level, suggested the subjects' marginality and displacement. The frame and the act of framing took on metaphorical significance. The photograph served as both a realist disruption and compassionate cue.

Much as he manipulates and fragments the photographic image, Jaar still seems to keep faith in photography's realist role as testimony and witness, and its subsequent potential affective or emotive power. His morally conscious global art exemplifies a non-cynical and humanist response. For all the appalling injustices and inequities witnessed, a certain utopianism remains.

[37] This work is included in Alfredo Jaar, *It is Difficult*, Barcelona: Actar, 1998.

Martin Parr, *New Brighton*, 1985.

Martin Parr, *Tokyo, Disneyland*, 1998.

Colour

At the same time in Britain, the mid-1980s saw attempts to use colour photography to reveal the waste and excess that accompanied the glossy consumerist façades. Colour, despite its associations with the spectacle of capitalism, showed up a Britain of neglect and decline — a decayed Northern seaside town in Martin Parr's portrayal of New Brighton, *Last Resort*, 1986, and the littered and dispiriting interiors of the country's unemployment benefit offices in Paul Graham's *Beyond Caring*, 1987. Pleasure and alienation respectively were located in particularly class-marked experiences. Both photographers evidenced the neglect and waste of a whole generation as Britain embraced a market-led economy under Margaret Thatcher. Parr's demeaning portrayal of working-class holidaymakers showed them seemingly oblivious to the litter around them, while Graham's surreptitious low viewpoint pictures of shabby dole offices showed the decayed condition of the Welfare State, and its neglect of a people, reduced to a state of inertia, waiting and queuing within a social system that had failed them.

By the time of his book *Common Sense*, 1999, Parr's vision had become global and his critique of consumerism more explicit, though at the same time the location of the experiences of consumption still tended to remain predominantly working-class and globalism was presented through a set of token and touristic markers of nationality. The pictures were taken in every continent of the world and the launch of the book was celebrated by simultaneous exhibitions in more than 30 different cities worldwide; exhibitions which filled gallery walls, blanketing them with multiple images. The book flags up its worldwide theme with the detail of a rusty and battered moneybox globe on its cover.[38] While some pictures clearly invite national stereotypes, difference is subsumed by the overriding uniform, repetitive act of consumption: the details and close ups of half-eaten food, of hands stuffing mouths with sweets, ice creams, burgers, popcorn and meats. And it is in this respect that one understands the full significance of the book's title: that the common sense is the sense we, we that is of the affluent West, have in common, a base sense of greedy over-consumption. Unity and commonality is, in Parr's vision, only found in greed. His picturing of the excesses of consumption is coupled with an entropic sense of waste and decay. Interrupting all the pictures of people stuffing their faces are certain abject details, suggesting a contemporary vanitas; a sticky lollipop dropped on the floor, a putrefying banana, a degraded bar code, a bruised apple.

Parr mostly avoids giving us identifiable pictures of people. He goes in so close we only see the consumers through punchy fragmentary details, bits of faces, a freshly lipsticked smile, a $100 dollar bill hanging out of a woman's mouth. Instead of human faces and expressions we have only the stunned, gaping looks and blank stares of grubby shop mannequins and sex dolls, their hollowness an analogue of the ultimate emptiness of the global consumer frenzy that is pictured.

[38] *Common Sense*, Stockport: Dewi Lewis Publishing, 1999. *The Last Resort*, Stockport: Dewi Lewis Publishing, 1998 (first published 1986).

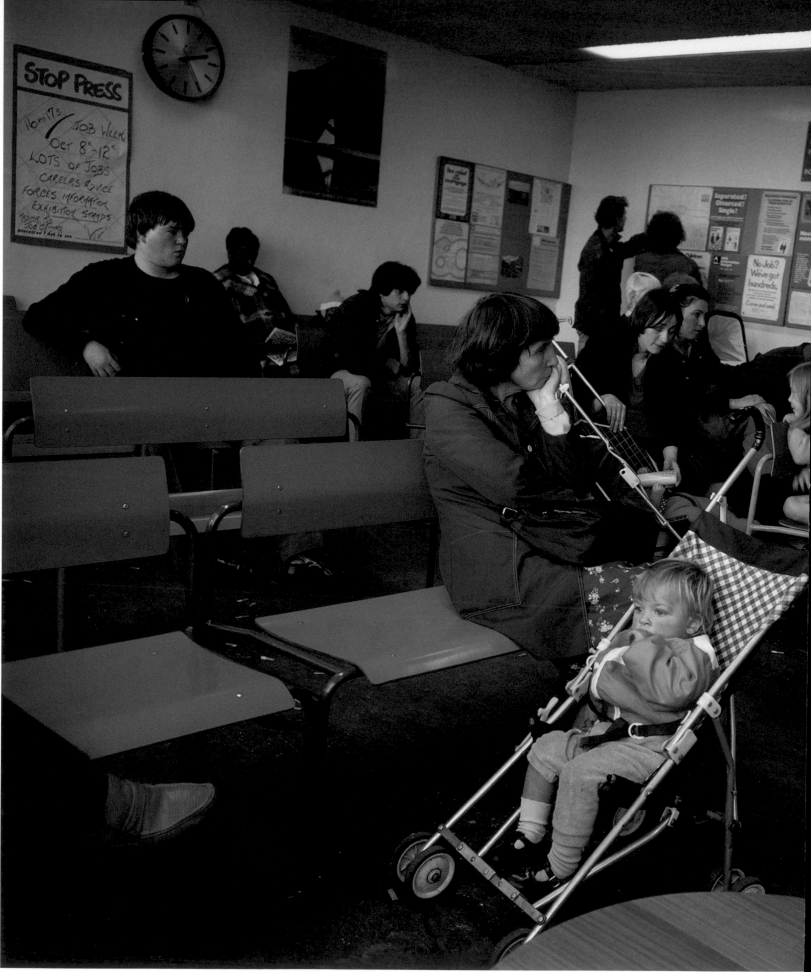

Paul Graham, *Mother and Baby, Highgate DHSS, North London*, 1984.

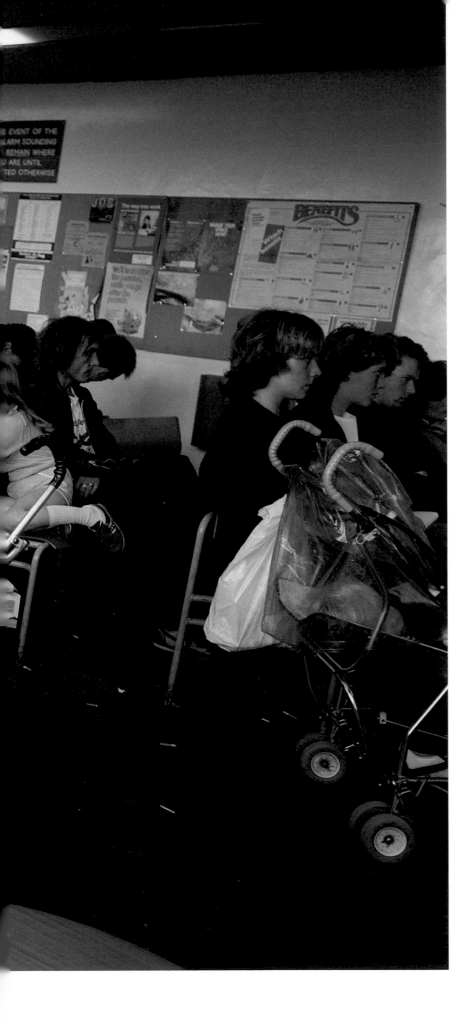

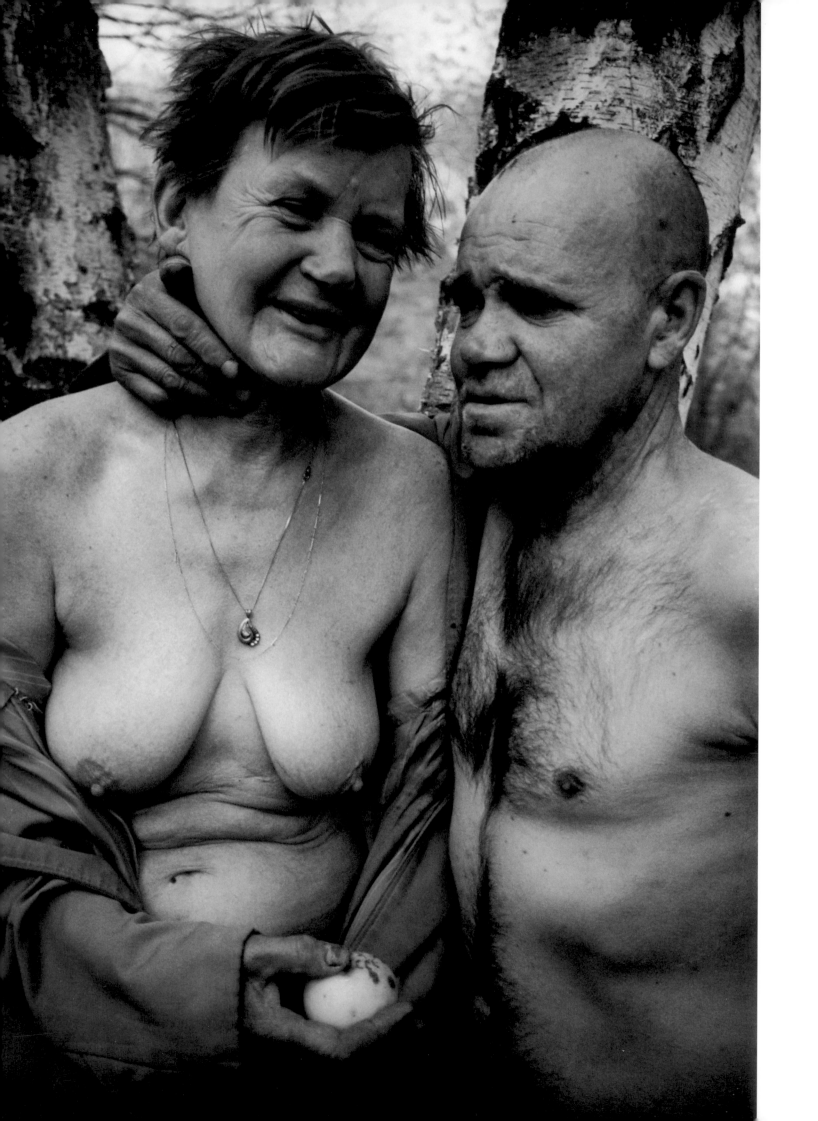

Dereliction

Common Sense finds an interesting relationship to Boris Mikhailov's *Case History*, also of 1999. In its emphasis on a state of decay and dereliction, Mikhailov's photographs extend the iconography of Parr's New Brighton, just as Parr's own *Common Sense* transposes the collisions of consumerism and waste in Northern Britain on to a global stage. Only Mikhailov's *Case History* is more grotesque and played out in a former communist state, the Ukraine. His photographs reveal the cruel and harsh effects of the crude capitalism imposed in the former USSR and highlight an analogous relationship between the body politic of the former Soviet Union and the actual bodies of some of its inhabitants.

Both Parr and Mikhailov could be seen to use photography to mime the dehumanising and alienating effects of capitalism. Mikhailov pays his subjects — the homeless, the 'bomzhes' in his native city, Kharkov — to take off their clothes and pose for him. The photographs are all in colour, some having the look and informality of snapshots.[39] The suggestion is that they are driven less by aesthetic considerations than by the historical imperative to record such powerful contemporary events. The very poverty and rawness, the aesthetic bad style of his photographs, also plays with a distinction between an affluent West and the economic desperation in the East.

Mikhailov has said that if his subjects were simply shown clothed they would continue to go unnoticed, remain invisible and inconspicuous. He seeks to restore them to visibility and dignity through photographing them in various states of undress. 'When naked', he said, 'they stood like people'.[40] While his pictures vividly evidence the loss of socialist communality within post-Communist Russia, Mikhailov describes and defends them in terms of the communality of a liberal humanism. He says that by removing 'the barrier of dirty, pongy clothes' from his subjects and revealing their nakedness beneath, we are meant to see and recognise 'our' common human condition.[41]

But with many of Mikhailov's pictures it is less a common humanity that we are shown but a base animality, borne out of a specific social context. These are often disfigured, scarred, bleeding and bruised bodies, wrecked human beings. Baring themselves naked to his camera very often also entails his subjects showing him their wounds. Such injured and damaged bodies serve as a correlative of the rotten and degraded situation of the post-Soviet states.

In *Case History* a knowing, international artist is clearly playing into Western fantasies of the former Soviet states; all those media images of a seething violent East that errupted in the wake of Communism's decline. Mikhailov himself has said how the experiment of socialism seems to be finished and we are probably witnessing its completion and that it is the latest period of that experiment which he documents. He describes how the project stems from his experience of returning home after a year away to a city that, while it had 'acquired a modern European centre' had a 'big number of homeless' and how 'before they had not been there.'[42] The rich and the homeless are 'the new classes of the new society.'[43]

Mikhailov describes the process of manipulating with money as being somehow a new form of legal relations in all areas of the former USSR. On one hand we have the necessity to document, a historical witnessing — as Mikhailov points out, in 'the history of photography of our country we don't have photos of the famine in the Ukraine in the 30s when several million people died and corpses were lying around the streets. We don't have photos of the war, because journalists were forbidden to take pictures of sorrow threatening the moral spirit of the Soviet people... The entire photography history is "dusted."'[44]

But on the other hand, his act of paying his vulnerable subjects to strip for him highlights the way in which Mikhailov is part of the 'non-ethical' capitalist art market,

Opposite – Boris Mikhailov, Case History, 1999.

[39] Boris Mikhailov, *Case History*, Zurich: Scalo, 1999.
[40] Ibid., p. 9.
[41] Ibid., p. 9.
[42] Ibid., p. 4.
[43] Ibid., p. 4.
[44] Ibid., p. 7.

feeding its seemingly insatiable desire for ever more sensational and extreme pictures.

With his abject subject matter, the exploitative transactions, the expressive, brutal wounds, Mikhailov expands the grotesquery and savagery in Martin Parr's photographs of capitalist consumption. In both artists' pictures there is little redemption. Their photography appears misanthropic, bereft of a humanist and empathic optic. In terms of their subjects, their view is marked by an essentially cruel relationship; the idealism of a socialist documentary vision has gone. Alfredo Jaar in this respect is Parr's and Mikhailov's obverse. While Jaar positions his art against photojournalism, and the quick relationship we have with the mass media, his work maintains its humanist and ethical faith.

Mikhailov proffers a phoney humanism as justification for his photography; we are all the same in our nakedness. But of course the display of his subjects' nakedness, the result of cajoling and manipulating his subjects with money, this base capitalism, plays with Western fantasies of an exotic, vulnerable and damaged other. He extends the anti-humanism of American artist Diane Arbus. Only Arbus' photography was marked by anger at the middle classes, the fakery of their cloistered worlds, and her gravitation to those outside such worlds seemed charged by a romantic identification. In contrast, Mikhailov's photography offers little space for affect and identification. His art testifies to the death throes of socialism, both through the brutalised realities he depicts and the exploitative way he takes his pictures.

Opposite – Boris Mikhailov, *Case History*, 1999.

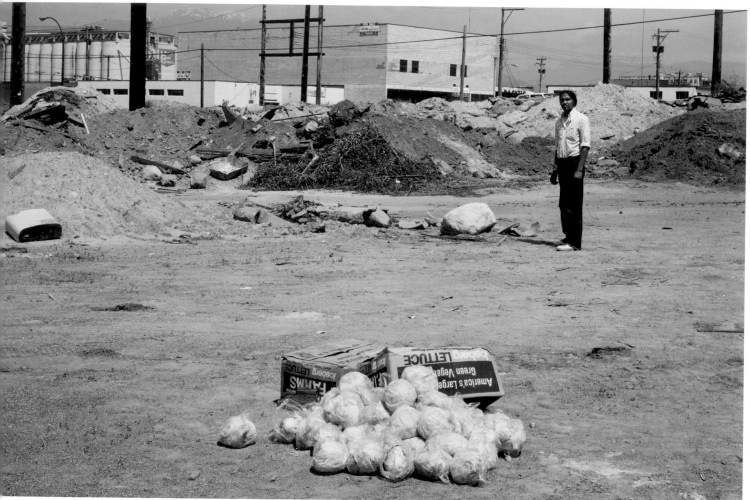

Jeff Wall, *Bad Goods*, 1984.

Bad Goods

Another important counterpoint to the Neo-Geo art of the 1980s was the work of the Canadian artist Jeff Wall. What was distinctive about his practice from the late 1970s was his post-conceptualist return to the picture and the pictorial, 'high art' pictorial, that is. Recourse to the tableau and the use of actors in staged and choreographed scenarios was a means of continuing a critique of documentary realism, but without Brechtian or Godardian strategies of distanciation which, by the mid-1970s, had become, according to Wall, 'formulaic and institutionalised'.[45]

Wall's practice involved a mimicry of the spectacle of public forms of late capitalism. Not the blank quotations of Pop but a mimicry augmented by an art historical knowingness and subject matter which would often appear to critique capitalism, with its familiar roll call of incidents replete with a sense of social violence and alienation.

The use of art history as a foil to the more lowly commercial associations of Wall's form, (the back-lit light box), preserves a cultural distinction and hierarchy. The recurrence of scenarios legible in terms of alienation, anger and social breakdown, and the contemporary settings, though often geographically confined to Vancouver, introduce a realist dimension, but one that trades on clichés, and a realism that is decorated and stylised, frozen in time, through citations from pictures in museums. Gestures and expressions often seem incompatible with those enacting them. Photography's awkwardness and wildness — a result of its contingency — is brought to heel by Wall, controlling and constructing the subjects and scenes.

[45] Jeff Wall's interview with Airelle Pelenc in Thierry de Duve et al., *Jeff Wall*, London: Phaidon, 2002, p. 11.

The recourse to the control of the tableau, and the reliance on expensive staged set-ups, means Wall's work is strongly authored. This and its renewal of the pictorial tradition distinguishes it from the work of the other artists of the 1980s. With the appropriationist art of Sherrie Levine and Richard Prince, we are not given new images. But both artists nevertheless open questions about the value and meaning of culturally familiar forms — Levine appropriates signature artworks, while Prince appropriates low cultural forms whose origins and authorship are much less certain.

Wall's authored pictures often set up an intellectual gamesmanship with the viewer. In *Bad Goods*, 1984, analogies are drawn between the waste-ground setting, the prominent foreground detail of a box of discarded lettuces — though in appearance seemingly unsoiled and still edible — and the solitary figure in the landscape, a British Columbian Indian. We are invited to read the figure's marginal and disempowered position in terms of the peripheral and neglected run-down landscape setting he is placed within alongside the discarded produce.

The recurrent blank looks of ennui in Wall's pictures trade on a Modernist cliché for alienation, drawn from Edouard Manet, as Wall's essay on the painter makes clear.[46] Wall refers to Manet's painting in terms of 'as a classicism of estrangement', a description equally apposite for qualities in his own work.[47] Manet's figures are seen to be both palpable, 'traditionally eroticised, and yet disintegrated, hollowed... they become emblematic of the new "fragmentary" type of person produced within capitalism, the person "who empathises with commodities."'[48] Manet's art, like Wall's, shows

us the alienating effects of consumerism and commodity culture. But in *Bad Goods*, alienation is not figured through the middle-class consumer of goods. The box of discarded lettuces becomes representative of the kind of substandard goods we are led to associate with the disenfranchised figure in the landscape. Wall's picture highlights the implicit racism of such a context. The correlations between waste, waste-ground, and the race of his subject in *Bad Goods* also echo the awkward correspondences being drawn between class and litter in a lot of 1980s' British documentary.

[46] Ibid., Wall's essay 'Unity and Fragmentation in Manet'.
[47] Ibid., p. 83.
[48] Ibid., pp. 83–86.

Manet's affront was the way in which he demeaned traditional values in art by the way his paintings related to everyday life in capitalism. Lisa Joyce and Fred Orton, in a recent essay, cite a contemporary critic of Manet who describes the way his use of shallow space in paintings such as *The Balcony*, is comparable to the way merchandise is displayed in the new shops of Haussmann's modernised Paris.[49] His paintings' very formal articulation of space made them analogous to shop windows and concomitantly set up a relationship with the viewer comparable to consuming.

Wall makes such an implicit analogy explicit in his photographs. The consumerist model for his pictures is both the shop window and the spectacular advertisement. However his big back-lit cibachrome transparencies illuminate subject matter that is familiar through a history of documentary not advertising.

In contrast to most documentary practitioners who produce a series of similar pictures, often working through a process of accumulation and repetition, Wall produces single images to articulate his points. His controlled and knowing pictures are bereft of the chancy and messier consequences of documentary practice and this need for more than one picture. But this comes at a price. The construction of Wall's images means that his pictures, as Joyce and Orton put it, have had to appropriate the necessary skills and competencies of cinematographic production 'as commodities available in the labour market' ie., actors paid to pose and perform, set designers, labourers hired to light sets etc.[50] The very mode of production of these works is labour intensive and expensive. Wall might use the spectacle of capitalist culture to illuminate scenes of social breakdown and alienation, but the full costs of his art always remain hidden.

[49] Lisa Joyce and Fred Orton, '"Always Elsewhere": An introduction to the art of Jeff Wall (A Ventriloquist at a Birthday Party in October, 1947)' in *Jeff Wall: Photographs*, Cologne: Walter Konig, 2003.
[50] Ibid., p. 20.

Richard Prince, *Untitled (Girlfriend)*, 1993.

Possessions

Richard Prince describes the adverts he rephotographs as 'Authorless pictures, too good to be true, art-directed and over-determined and pretty much like film stills, psychologically hyped up and having nothing to do with the way art pictures were traditionally "put" together.'[51] In cropping, editing and sequencing commercial pictures, Prince exploits the seductive power of adverts. Is he collusive with corporate culture? Is he critical of it? If so, what is the nature of the critique?

One could argue that there is a sense in Prince's rephotography of adverts, of an over-embellishment; of an aesthetic enhancement having gone too far. They are too slicked up and we sense the plastic artifice. The facial colours of his models do not look like flesh, and are rendered mannequin-like. An interesting reversal takes place with Prince's retouching of media archetypes and we sense the construction. The idealised images are deformed and spoilt in the process and this very alteration at the surface suggests something more.

Prince's work displays an uninhibited fascination with vernacular and sub-cultural forms of photography, in particular his rephotography in *Girlfriends*, 1993 of snapshots of bikers' girlfriends, often posing topless or riding on the bikes. In this series, there is a slippage between the way people wish they could look and the reality of their appearance. Here are less embellished pictures. In the case of *Girlfriends* they look to glamour photography but fall short, a gap between the ideal and the actual. The images used by Prince in the *Girlfriends* series were taken from biker magazines that had invited their readers to send in photographs of their bikes, invariably accompanied by their girlfriends. In their flawed realisation the posed images almost function as a demonstration of how not to present products: stiff poses, bad lighting and off colour. Given the nature of their original context, the inclusion of 'girlfriends' in photographs of bikers' 'possessions' is as predictable as it is sexist. Prince's work centres on the fact that his subjects are presented as commodities, however imperfect, and his ability to accentuate the methods employed by the marketing industries to beguile.

As Luc Sante puts it, Prince 'returns with raw material distinguished by its hostile distance from the art world, which he then submits to the protocols of that world.'[52] In *Car Hoods*, 1987-1990, Prince uses specialist car magazines to source and buy component hoods for American muscle cars, which are then customised with cool Minimalist paint jobs. When mounted on the wall, these eroticised objects of male desire wryly revisit the Minimalism of John McCracken and Robert Mangold. They are symbols of an American 'cool', trading off both the refined aesthetic of Minimalism and popular culture's fascination with speed, glamour and death.

The point for Prince is that he is directing, manipulating and retouching readymades, both objects and pictures that have already been retouched and manipulated. His art is caught up with the desires and fantasies that circulate around commodities. His most famous images of the 'Marlboro Man' cowboy speak about nostalgia for a heroic past. He started to use the figure after the marketing company stopped using the imagery. To this extent the image can be understood as a form of promotional debris, a remaindered image, depleted and no longer useful. There seems something cuttingly ironic that the mythology of the Wild West, iconic of American democracy and independence, was used to sell a product that is addictive and creates dependency. Much as Prince's photographs might be read as a critique of the conditions of commodity fetishism, his own work is subject to the same fate. One of his photographs from this series has now accrued its own notoriety and fame as an expensive art commodity: the first photograph that sold publicly for over one million dollars.

Overleaf – Richard Prince, *Untitled (Cowboy)*, 1989.

[51] Interview with Jeff Rian in *Richard Prince*, London: Phaidon, 2003, p. 12.
[52] Ibid., p. 77. Luc Sante's 'Focus' essay on *Untitled (Girlfriend)*, 1999.

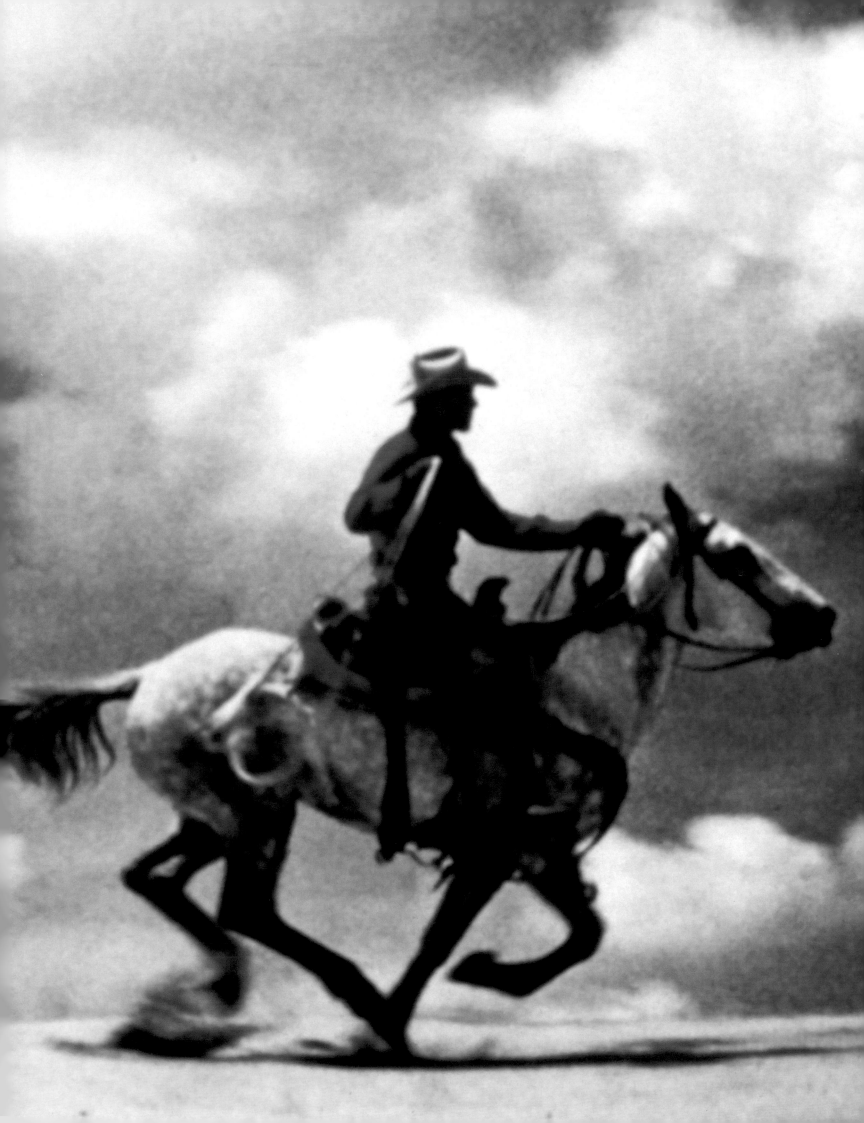

Richard Prince, *Car Hoods*, 1987-1990.

Prince's fascination with vernacular and popular forms of culture and their intersection with high art continues with his *Joke Paintings*. This series, begun in 1987, deploys text and the generic graphic style of 1950s' cartoons to deliver crass, familiar jokes, indexing the fears and fantasies of suburban America. It is fitting that Prince has used the joke format so extensively as a vernacular readymade; it is thoroughly embedded in popular culture and circulates through a well-understood system of appropriation. Jokes are meant to be borrowed, used and passed on; they are intrinsically social. No one seeks to 'own' a joke and yet Prince, through his re-presentation of the form as a *Joke Painting*, stimulates just such a desire.

A traveling salesman's car broke down one evening on a lonely road and he asked at the only farm house in sight. "Can you put me up for the nite?" "I reckon I can," said the farmer. "But you'll have to share the room with my young son ." "How about that!" gasped the salesman. "I'm in the wrong joke."

Richard Prince, *The Wrong Joke*, 1989.

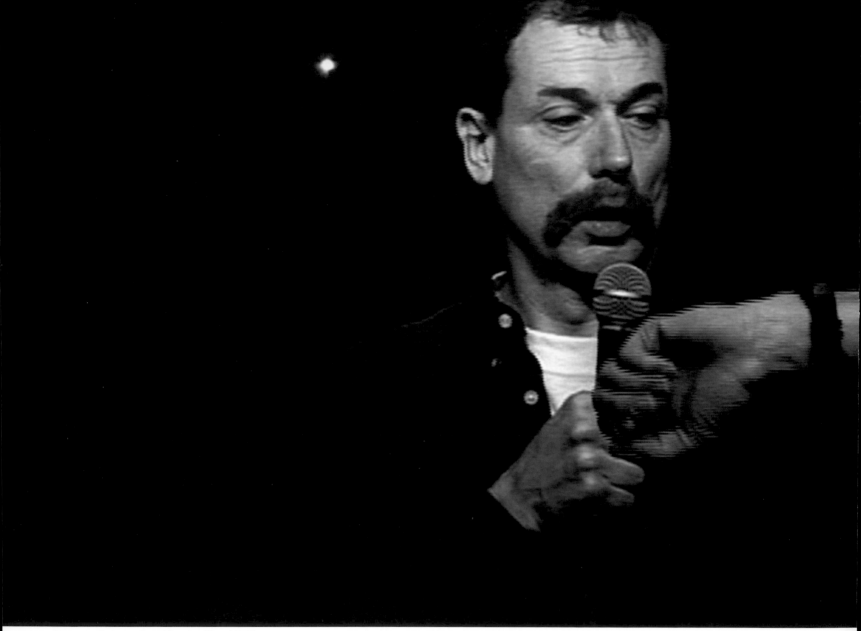

Common Culture, *Local Comics (Dave)* 2005.

Common Culture

Common Culture's collision of venerated and vernacular cultural forms is motivated by an interest in how issues of taste, class and notions of national identity are negotiated through the transaction of commodities within British popular culture. In their *Menus* sculpture, which forms part of their *Counter Culture* work, 1997-2000, allusions to the format and serial arrangement of Donald Judd's coloured, three-dimensional objects are combined with the garish signage of illuminated British fast food menus.[53] The work mimics Minimalism's formal purity only to inflect it with industrial signage, designed to incite mass consumption.

In one sense the *Counter Culture* work reverses the direction of Minimalism's engagement with industrial society; while Minimalism borrowed forms and serial fabrication processes from the urban scene — the fluorescent lights of Dan Flavin, the industrial materials of Robert Morris and Donald Judd — the specific source materials became aesthetic, rarefied objects, isolated in the white cube gallery. Common Culture's adapted coloured menus carry the trace of a particular relation to the British urban scene, their specific sources are written all over them in the variety of dishes on offer. The work articulates the experience of life in a regional, urban, working-class environment in a multi-cultural Britain, where the legacy of empire illuminates the high street in the form of fast food restaurants luring people to consume dishes from Hong Kong, India and Pakistan; a place where chicken tikka massala is deemed to be the most popular British fast food dish.

The *Menus* highlight the conventional nature by which culture is consumed, and introduce through the conflation of opposing cultural conventions — that of the chip shop and the gallery — a kind of queasy unease in the reading of the work.

Spectator unease, the creation of awkwardness between the artwork and its reception, becomes the defining feature of Common Culture's *Pop Trauma* work, 2005/6. In a series of staged performances, workers employed in popular entertainment — stand-up comedians, tribute singers, mobile disc-jockeys and night-club doormen — are each hired and filmed delivering a slightly modified version of their specialist services. Their live performance and its video recording continue Common Culture's exploration of commodity consumption by addressing the social relations involved in the commodification of human labour power and its representation as art.

In *Local Comics*, individual comedians are filmed performing their act in an empty comedy club. Each routine is recorded by a stationary video camera, positioned so that it gives a close-up head and shoulders portrait of each comedian. The video starts and finishes with the empty stage; the comic walks on, delivers his or her routine and then walks off, leaving the videotape running. The format is identical, emphasising the repetitive and standardised nature of the commodified comedy form. Most routines last approximately twenty minutes, some longer, others painfully unravel in less time. Duration seems to depend on the performer's confidence, professionalism and range of material.

All of the comics are instructed to deliver their normal routine; the only difference is that they are asked to do so to a solitary video camera without the presence of an audience. Playing to an imaginary, absent audience, the performers trawl through the complexities of everyday life, finding temporary solace and accommodation in the witty anecdote and the 'joke'. But unconnected to any audience response, their carefully timed performance spills into the void of the club. The spectator of Common Culture's *Local Comics* witnesses the comics' struggle to balance the rehearsed control of the professional with the panic of someone who knows all too well the routine nature of their 'entertainment'.

Overleaf – Common Culture, *Colour Menus Installation*, 2002.

[53] Common Culture, *New Menus*, The Real Gallery, New York, 1997 and *Common Culture: Counter Culture*, Cornerhouse Gallery, Manchester, 12 March – 12 April 1999.

Delivered as a form of popular entertainment, the comics' observations are fuelled by their own social experience, informed by a sense of who they are and how they relate to a world they share with their audience. Their 'local' views on the 'big' issues of relationships, sexuality, race, class, gender and politics mark their stories as funny and potentially insightful. But their observations also reference a world where tradition is framed by constant flux, where often remote, transnational social forces determine individual experience. To some extent the comic's act is a litmus test of how this change is experienced and articulated by local communities, often providing a self-conscious show of resistance to the globalising tendencies of the market, through creating comfort in the inflation of local and national distinctiveness. According to Alison Rowley 'what shows in these "turns", beyond the varying comic abilities and personality of each individual, might be characterised as cultural melancholy; the desperate, but inescapable repetition of a near redundant form of live common culture, associated originally with the white industrial working class, that has a history as both a form of resistance in class struggle – piss-taking – and of precarious escape from it through talent and skill. Media commodification – I guess starting with TV variety shows – has neutralised the former, while the cult of reality TV celebrity has radically devalued the latter.'[54]

Paying comics to perform for as long as they are able to an empty room is a test of their professionalism, nerve and the power of the contractual obligation that holds sway between the buyer and seller of labour power. The therapeutic yield normally gained from the comics' relationship with a familiar audience is severed by the instruction to perform to the solitary video camera and is replaced by yet another process of commodification, when the performance of their act is filmed and re-presented to another audience as art.

In *Local Comics*, the comedians' polished commodity, their 'routine', is deprived of its fluency by Common Culture's intervention. The spectators' experience of viewing the video of this performance as an art commodity is fraught with discomfort and embarrassment, prompting them to question their own relationship to this network of exchanges.

Common Culture's series of performances, videos and photographs, *Bouncers*, begun in 2005, addresses the tensions involved in the management of cultural power and the control of disruptive forces. It sets the controlled looks and presence of people whose job it is to manage the control of consumers, against the consumers of art. For the live event, fifteen bouncers were hired to adopt and maintain a confrontational geometric configuration in the gallery for the duration of the opening night of the exhibition. Drawing upon the rhetoric of Minimalism, the piece is meant as an aggressive work, impolite in relation to the viewing public. It extends

[54] Alison Rowley quoted in *Common Culture – Pop Trauma*, Derry: Void, 2006, n.p.

portraiture to real life subjects, whose job is about knowing and controlling looking at others. At the same time the bouncers are disempowered, subject to the look of the art crowd, they become a spectacle. A dialectical tension is set up between the live work and its viewers.

The photographic portraits of the bouncers extends and magnifies their hard, public front, their inexpressivity and inertia — a certain blankness that is not about 'anomie', but something that is integral to their working identity. For all the self-composure and commanding presence of their subjects, the photographs are unrefined. Details bring out slippages in the desired self-image, aberrations that spoil the self-managed and controlled looks to camera. In the video, the camera circles

the formation of bouncers, each subject in turn taking up and following the camera's movement with their gaze, an address of menace. What is interesting is that the camera allows us to see the formation and cultivation of this look, as some can be seen preparing to adopt their look to camera as it comes towards them. *Bouncers* deliberately highlights the reality that labour-power is just another commodity, and is treated no differently by the market than any other form of commodity. What is so unnerving, especially in light of their 'hard man' reputation and intimidating physical presence, is the utter compliance of the bouncers.

For Common Culture, Minimalism's concern with the management of the formal/social boundary of the

artwork and the desire to impart in the viewer an awareness of it as being situated in a specific context had an immediate correspondence in the function of the nightclub bouncer. Bouncers were hired because they police the interface between the public and the private commercial sphere of leisure. Common Culture's use of hired security staff, to 'manage the door', was a deliberate strategy to address the issue of power in the control of social space. The bouncers are simultaneously 'hired muscle' serving the interests of capital, and a representation of a form of brutalised, commodified labour. The uniformity of styling, the short hair, the manicured beards of the bouncers and their ability to engender acute self-consciousness in the

viewer, presents another opportunity to re-engage with Minimalism.

This collision of looking, orchestrated between the visitors to the gallery and the bouncers' stare, was central to the performance. The professional stare of the bouncer, unflinching in some of the men, but more ambiguous and complex in others, and the active way they engage with the gallery visitor's look, prevents their categorisation as merely statuesque. Surprisingly, the 'hard-man' front presented by the bouncers was clearly fractured with anxiety, vulnerability and even something that looked like sadness, mixing uncomfortably with their macho bravado.

Overleaf – Common Culture, *Local Comics, Lou and Mike*, 2005.

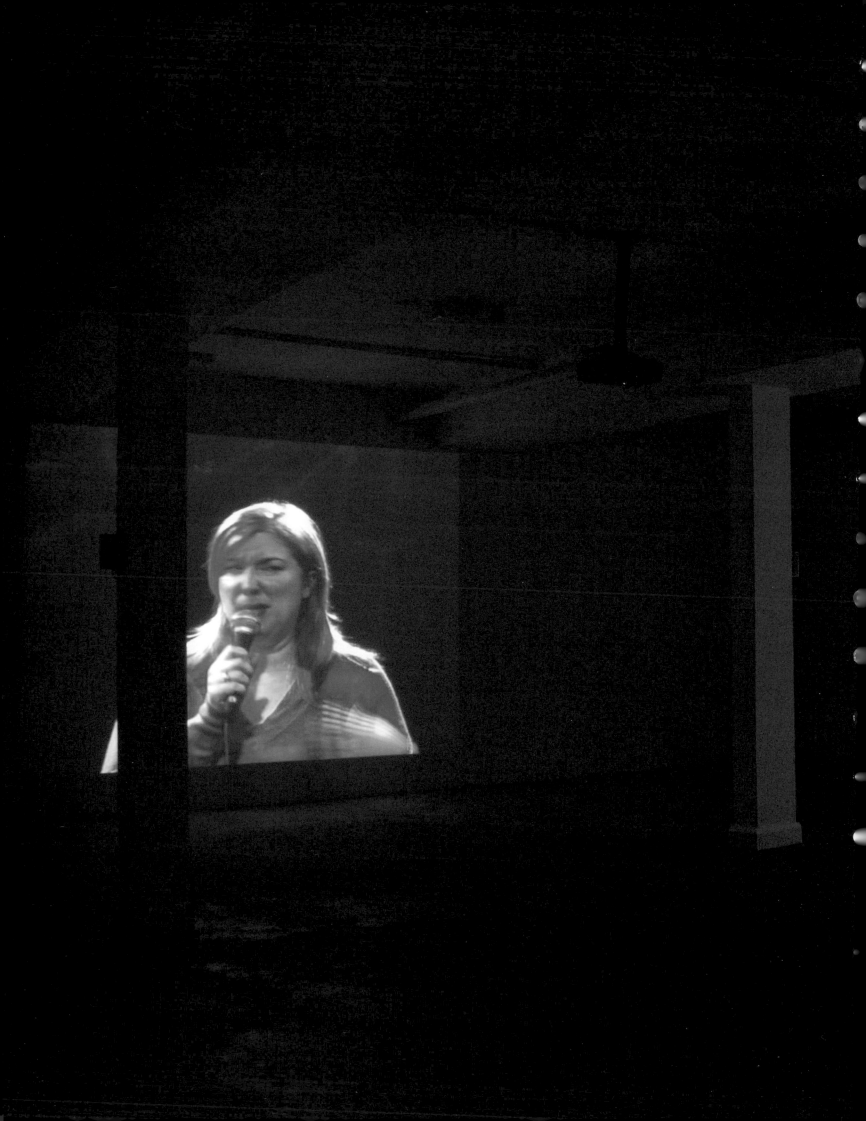

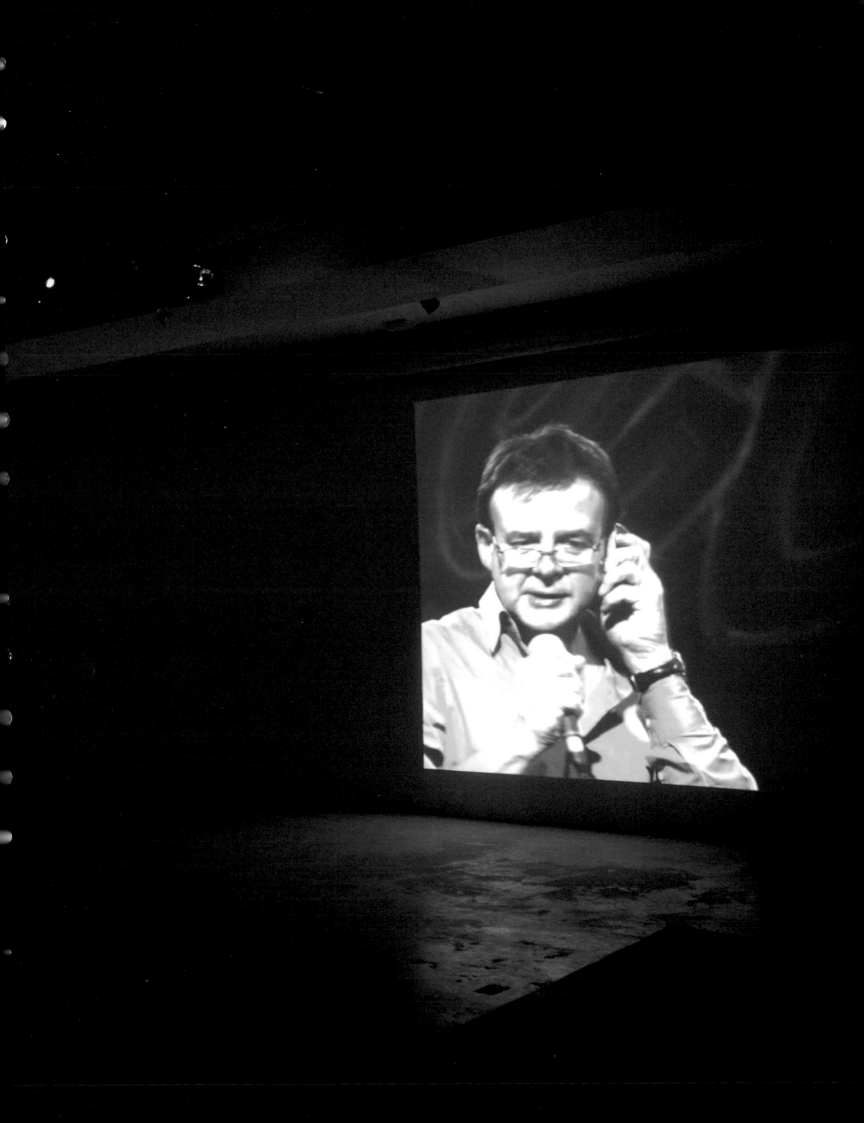

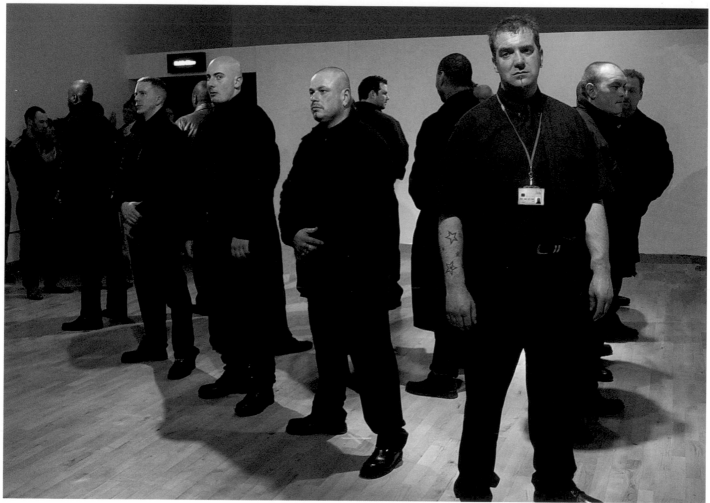

Common Culture, *Bouncers, Performance Installation*, 2005.

Common Culture, *Bouncers, Portraits*, 2005.

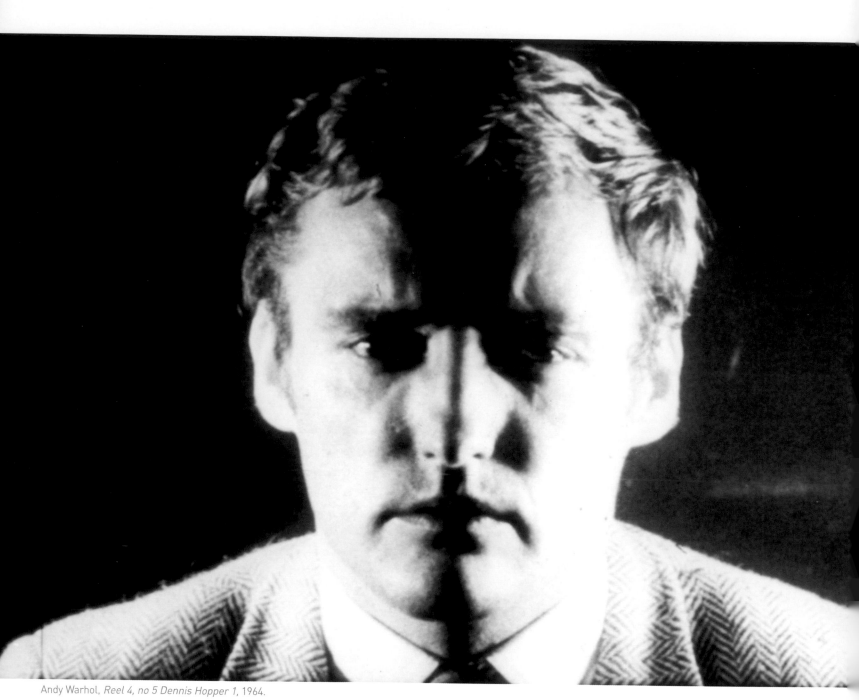

Andy Warhol, *Reel 4, no 5 Dennis Hopper 1*, 1964.

Screen Tests

Andy Warhol made nearly 500 *Screen Tests* between 1964 and 1966. They function against the artifice of Hollywood film and also might be seen to counter his fascination with the surface allure of stardom. Here is something that seems to offer more substance and depth than the glitzy, phoney aura of his celebrity silkscreen paintings. In these interrogative, voyeuristic and slightly erotic studies, each of his subjects was instructed to hold a fixed pose before the movie camera for the duration of a one hundred foot 16mm film cartridge.

Unlike conventional screen tests undertaken in Hollywood, Warhol's tests are things in themselves, not just the try out or preliminary, leading to a contract and a career in 'proper' movies. The fact that they all have equal value, and have not been judged nor ranked in order of 'star' quality, is telling, as is the sheer number of them. The industrial approach to their production is equally interesting; a conveyor-like stream of 'faces' submitting to Warhol's dispassionate camera – a mixture of chronic attention seekers and those lured by the glamour of Warhol's factory. They are the raw stuff of New York's bohemian underworld of the 1960s, where drifters, psychotics and junkies mix with the artworld and the pampered offspring of the ruling elite, and yet the tests bestow a bizarre kind of equivalence on those filmed. At a technical level, with each test using up one film cartridge, the filming process standardises the individual's test to a common format. Like Campbell's soup, no matter which individual variety is sold, they all end up in the same kind of can.

Warhol's silkscreens are polarised between the repetitions of portraits of glamorous stars and the anonymous dead in his *Disasters* series. Benjamin Buchloh talks about them in terms of 'collective scopic compulsions: looking at the Other (in endless envy at fame and fortune and in sadistic secrecy at catastrophe...).'[55]

In these works, fame is fixed by something that people either have done (the star celebrities) or had done to them (the victims of disasters). In both cases, the 'fix' is the celebrated event that warrants their inclusion as famous/infamous and this is matched by the literal fixing of the static silkscreen image. There is a shift from the movement of live events to that captured and fixed by the camera as the perpetually static moment, the decisive moment, if you like, of the photographs that Warhol uses.

With the *Screen Tests* there is a different relationship between events, time and the artwork Warhol ends up with. The actual process by which the image is produced, while clearly related to the conventional Hollywood screen test, is nonetheless very different. The sitters are given no clear instruction as to how to perform and have to fall back on what they think Warhol expects of them or what they think they should be delivering in a screen test. In other words, they play out what they think the

recognisable characteristics of the commodity 'star' are. The *Screen Tests* also reveal their relation to static photography's preoccupation with the 'decisive moment', which is about making a value judgment about when to press the button. When Warhol starts the camera and then walks off, the screen tests forcibly assert that the duration of normal everyday time is made up of moments that are usually indecisive, in the photographic use of the term. But in the culture of the commodity, 'celebrity' is an interruption of the norm, a moment, the flash of a camera and the fix of an image. There is something of this in the popularity and currency of Warhol's comment about fame and 15 minutes. Celebrity as a fixed moment, a fixing of distinctive individual characteristics, the presentation of a trade-mark, takes place in a continuum of consumption in which the 'new', that which is celebrated, is not any one person or event but a *function* that has to be continually renewed. The '15 minutes quote' is not in any sense a qualitative judgment,

[55] Benjamin Buchloh's essay 'Andy Warhol's One-Dimensional Art' in *Neo-Avant-Garde and Culture Industry*, Cambridge MA and London: MIT Press, 2000, p. 502.

Andy Warhol, *Reel 24, no 7 Marcel Duchamp*, 1966.

Andy Warhol, *Reel 11, no 4 Susan Sontag 2*, 1964.

but rather a quantitative one. It speaks about a culture little concerned by the content of that 15 minutes other than that it should be new and of a probable and consistent type of newness, i.e. one that is recognised as fulfilling the criteria of being worthy of celebration. And what is worthy of celebration in capitalism is ultimately the commodity. So Warhol reveals the nature of celebrity as the ability to fulfil the role of the commodity. The *Screen Tests* are intriguing because we witness a procession of individuals acting the part, some unfazed, resistant or knowing, others dazzled and flattered. All of them adjust to their role as a commodity to be looked at.

Warhol's decision to project the films at silent speed (16 frames per second, or a third slower than normal speed) prolongs each film to the duration of four minutes. The effect is a barely perceptible slow motion. Reality is transformed; this is not literal time, despite the seeming literalness and directness of his strategy of

film production. Slowing things down, as Stephen Koch puts it, 'is a technique that faintly dislocates the pressure of real time, extends it, and makes it just slightly Other, in a lush, subtle experience of movement and time possible only in film.'[56]

Before Warhol's films 'we find ourselves voyeurs at both a proximity and distance no voyeur could ever know, both near and far away as only the camera can be, unreal with its minutely recorded literal reality.'[57] Reality in its minuteness is drawn out, and 'flesh becomes filmic'.[58] Warhol embraces the distancing and alienating vision of the camera, turns the alienation into an aesthetic. There are accounts of his passive absorption in his films: Ronald Tavel, for example, in conversation: 'I know what you mean by saying that Warhol's central metaphor was voyeurism, and it was an inescapable conclusion on my part, just from watching him watch the films, like the twenty-four hour film *Couch,* which is just twenty-four hours of people coming in and having

sex in all different ways on this couch. He would sit and watch it with such contentment that I felt I was in the presence of a Buddhist who had achieved the desired transcendent state. Total satisfaction and total calm. Though in his case it struck me as being a necrophilia too; because what he was trying to move toward in the films was a stillness.'[59]

But is this stillness about the films approaching the condition of the dead, or perhaps, approaching the condition of the *inanimate*? It is almost as if the slowing down of the film is Warhol's way of showing the process of commodification as it applies to actual human subjects. He achieves this with inanimate consumer products in his objects and silkscreens, and through the reproduction and serial repeat of the Elvis and Monroe portraits, which suggest a stuttering kind of movement or shudder.

Warhol's art entails a 'stare of distance, indifference, of mechanically complete attention and absolute

contactlessness.'[60] The Bolex film camera's unblinking, staring eye is integral to his 'alienated vision.' The camera is not given the vivacity of the gaze, but instead Warhol 'reinstates the camera in its condition of being a dead machine'.[61]

Does Warhol commodify alienation? His star celebrity status rested upon his persona of indifference and passivity, of not being expressive or emotive. He made alienation cool and chic. The *Screen Tests* trade upon his aura and fame. It's his fame that gets his subjects to participate.

The *Screen Tests* exemplify the way Warhol used film in other early films. With *Sleep, Kiss, Eat,* a motorised Bolex was set up, loaded with one hundred foot magazines, and filming lasted until the magazine ran out. Editing consisted of gluing together each take, leaving in the whitening emulsion and the perforated tags on the end of each roll. In *Sleep,* he varied viewing positions with each new cartridge.

[56] Stephen Koch, *Stargazer: The Life, World and Films of Andy Warhol*, London and New York: Marion Boyars, 2002 (first published in 1973), p. 43.
[57] Ibid., p. 43.
[58] Ibid., p. 43.
[59] Ibid., p. 41.
[60] Ibid., p. 31.
[61] Ibid., p. 32.

The *Screen Tests* in their sheer quantity begin to serve as an anthropology of a certain optimistic and decadent moment in 1960s' New York culture. There is irony in the immobility and slowed down pace of these portraits of an often amphetamine-fuelled subculture. In capturing the parade of people, anonymous and famous, that formed part of Warhol's entourage in the silver-walled Factory studio in the 1960s, there is equivalence as all are given the same exposure before the camera. The relative serial uniformity of the process — there are still variations in lighting, exposure, background, framing — points to a certain democracy. One could also see it as standardisation, which speaks more of the product's uniformity. When Warhol stated 'I think everybody should be a machine', he drew attention to his interest in uniformity, 'because you do the same thing every time. You do it over and over again.'[62]

Andy Warhol, *Reel 25, no 10 Ann Buchanan*, 1964.

[62] Andy Warhol, 'What is Pop Art?', interview by G.R. Swenson, *ARTnews*; 62, no.7, November 1963, p. 26.

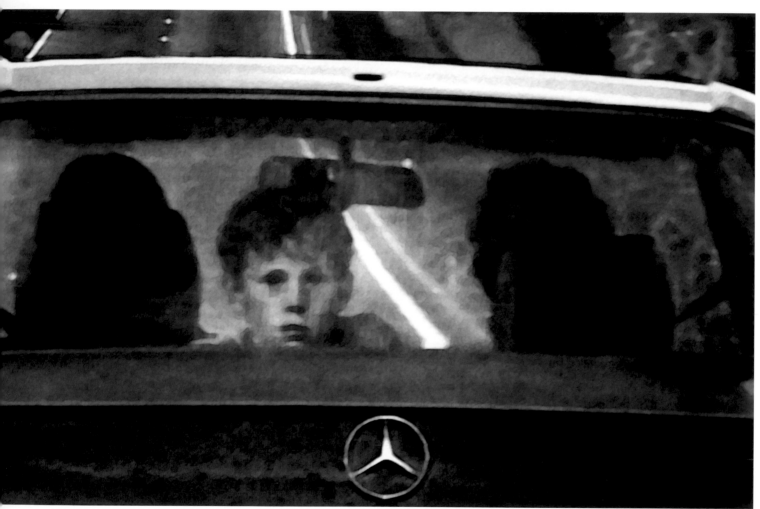

Hans Op de Beeck, *Determination 1*, 1996.

Treadmills

It can be argued that the deferral of arrival, the withholding of satisfaction, is one of the fundamental forces driving contemporary capitalism. After all, consumerism is predicated on constant consumption, and while capitalism may promise satisfaction, the economic bottom line is that it cannot afford to deliver it. The stimulation of desire and demand is the motor force of any consumer culture and the consumers' appetite to want more must be perpetually sustained by their capacity to generate capital. This twinned movement, tying the flow of commodities in a cycle of consumption to the constant generation of capital, is neatly represented by Hans Op de Beeck's use of mechanised devices such as escalators, supermarket conveyor belts and treadmills.

The Flemish artist's practice seems shaped by a dialectic that shifts between movement and stasis. When action does occur it is usually animated by the monotonous operation of a mechanical device: the movement of a car, an escalator, a treadmill, or in *Situation 1*, 2000, a conveyor belt and the slow panning of the camera down the checkout line of a huge supermarket. But even here the scene is infused with lethargy as the bored checkout assistants wait for customers that never arrive. A place of consumption is stripped of consumers. The only action is the ponderous movement of the camera as it pans down the line of tills.

In the video *Determination 1*, 1996, a child gazes out of the rear window of his family's Mercedes as it travels along the road. Bored and distracted, the young boy peers back at the viewer. Interrupting our view and the boy's trance-like gaze hovers the Mercedes' corporate logo. It seems that Op de Beeck may well be insinuating that both the child's and the viewer's gaze are subject to the same alluring charm of the prestige car's logo, both are mesmerised by its social status. The Mercedes is both a vehicle for actual transportation and a sign for aspirant social mobility.

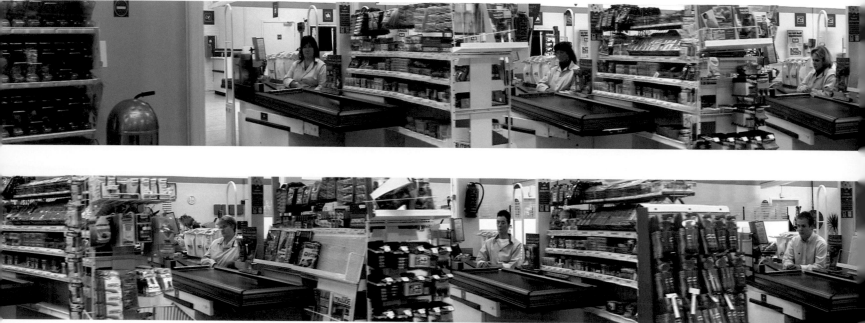

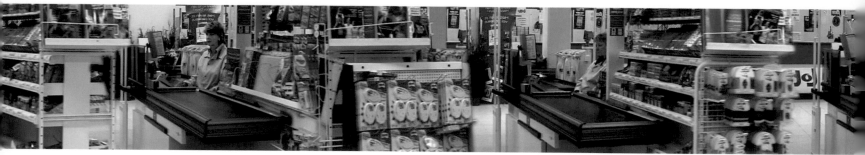

Hans Op de Beeck, *Situation 1*, 2000.

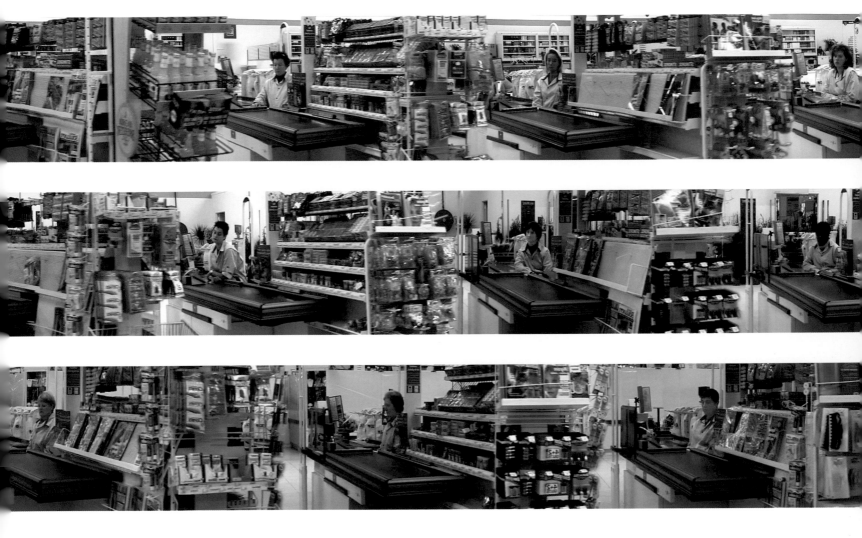

This journey will never end. It is held within the perpetual motion of the tape loop, subject to the dread of that familiar cry from the back of the car, "are we there yet?" But in this work, one gets the sense that for Op de Beeck the answer might indeed be 'yes', that the destination is nothing more than our relentless quest to keep on moving, and in this sense we have already 'arrived'.

Similarly, in the video *Sub*, 1997, the camera endlessly journeys down an escalator. First used in Bloomingdale's department store in New York in the nineteenth century, the escalator is a familiar device, designed to bring about the orderly and effortless delivery of shoppers to the retail spaces in which they can realise their role as consumers.

Hans Op de Beeck, *Sub*, 1997.

Hans Op de Beeck, *Insert Coin for Love*, 1999.

Insert Coin For Love, 1999, shows the mechanics of a peep show booth. We view the video from the position of a consumer, and can only see the film once we put money in an arcade machine. But we are short-changed; the woman does not perform. Rotating on her red velvet podium, she remains clearly bored and indifferent to the viewer, she yawns at one point, conspicuously refusing to deliver what is expected of her. Again desire is frustrated and instead we encounter this awkward performance, as if we had looked behind the scenes and glimpsed the numbing routine of commercialised sex, in which any pleasure for performer and viewer is removed.

In Op de Beeck's *Determination (4)* 1998, a life-size video is projected onto the wall. It shows a couple and two children, the archetypal nuclear family, with their feet positioned exactly at the level of the gallery floor, walking and running towards the viewer. Set against a white background, the family unit is abstracted from its environment and context. The expressions of the well-dressed figures make it clear that they are not running away from a threat. These are not the expressions of fear or anxiety, nor are they the look of excitement or anticipation, but instead the stoical acceptance of the fact that this is what has to be done. Our initial interpretation of the family's perpetual motion, in clothes more suitable for shopping than jogging, suggests that this could be a family of shoppers rushing to the Spring sales.

But the family's perpetual physical effort begins to read more like time spent on a treadmill, expending energy in the quest for health and fitness but actually going nowhere.

In so doing, it pushes the interpretation of the movement as a form of training to improve one's fitness, and, after all, are we not constantly reminded that in a competitive market economy only the fittest survive?

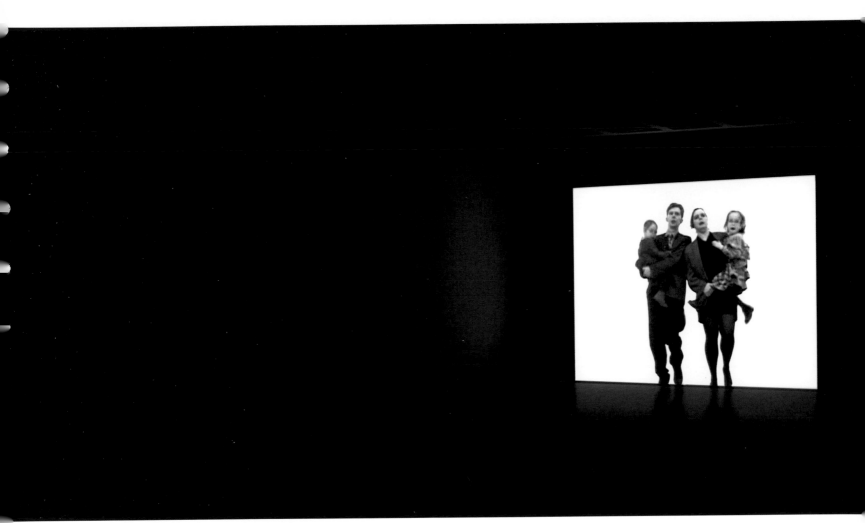

Hans Op de Beeck, *Determination (4)*, 1998.

Julian Rosefeldt, *News*, 1998.

Standardisation

As capitalism developed, bringing about the rapid expansion of world markets and the increased globalisation of production, the relationship between the producers and consumers of commodities has become ever more distant. In the past, societies were often marked by an intimate geographic proximity between the production and consumption of goods. This relationship was both economic and social in character. As capitalism developed further, opening up new markets and securing cheaper production costs further afield, the social relationship between producers and consumers, based on a form of spatial proximity, began to dissipate. Fragmentation and the displacement of communities are intrinsic features of global capitalism, bringing with them the dangers of social disintegration and the possibility of political unrest. It is one of the many ironies of capitalism that because of its incredibly dynamic nature, it must constantly maintain a form of social stability that will enable its continued reproduction as an economic system. Adorno argued that the culture industries of advanced capitalist societies manufacture mass or popular culture to manipulate the needs and desire of citizens so as to distract them from recognising their own exploitation under capitalism and dissuade them from doing anything about it. According to Adorno, this results in a tendency to homogenise and standardise experience so as to maintain the semblance of order and ensure the continued reproduction of capitalist society.

Julian Rosefeldt's work explores the standardisation of experience brought about by globalisation and the role mass media plays in narrating this reality. As the experience of contemporary society becomes ever more fragmented, it appears that the media, and in particular the news media, has taken it upon itself to play the role of providing harmonising narratives to soothe the complexities of everyday life. Fuelled by the assumption that it represents the values, interests and concerns of its audience/market, it feeds us a daily diet of supposedly responsive and objective reportage. In the video/sound installation News, 1998, Rosefeldt dissects this assumption, sifting through media archives to amass a huge stock of images taken from television news broadcasts. He interrogates the glut of images pumped out by the news media, categorising the reccurring elements to reveal their formulaic and repetitive nature. From the standardisation of the editorial style, to the newsreaders' appearance and the facial expressions they deploy, News reveals the production of the daily news as a banal process of reiteration, endlessly using stock conventions and formats to create a consumable 'reality'.

The formulaic nature of expression highlighted in News is further developed in Global Soap, 2000/2001. In this work, presented as a four-screen photo/video installation, Rosefeldt continues his exploration into the banal and repetitive nature of mass culture. Enlisting the assistance of some of the many offices of the Goethe Institut located around the world, Rosefeldt accumulated recordings of television soap operas screened in their host country.

Global Soap addresses the standardisation of cultural expression across the world. The work explores how universal types of gesture and expressions emerge through the model of the television soap opera. For Rosefeldt, the ubiquitous television soap opera is the ideal vehicle with which to examine the standardisation of cultural expression. As a cultural form it is avidly consumed in most countries that have a television audience, it is massively popular and for many viewers provides something akin to a surrogate social life, with fictional family and neighbours getting up to all sorts of shenanigans. The emotional intensity of the drama and the identification by viewers of 'believable' story lines ensures that as a format, television soap operas dominate the programming schedule.

Julian Rosefeldt, *Global Soap*, 2000/2001.

They have a huge impact on how viewers across the world understand and narrate their daily lives. A strong sense of moral instruction underpins most soap operas, with story lines tending to consolidate the dominant value system of the society in which the soap is set.

Rosefeldt's *Global Soap* unpacks and classifies the component parts of the soap opera form. Using material taken from programmes recorded in different countries, he pieces together an iconographic map that makes startlingly clear the uniformity of the expressive language developing across the genre.

Whether screened in Mexico, China or the UK, soap operas increasingly share similar storylines, set locations and character types. *Global Soap* illustrates the development of a homogenised and universal vocabulary of gestures, where actors appearing in national soap operas perform as if they were merely local versions of a single universal type.

Julian Rosefeldt, *Global Soap*, 2000/2001.

Exploitation

What is so absorbing about the work of Spanish artist Santiago Sierra is the deft way he brings to light the routine subjugation necessary for the smooth operation of capitalism. In his performance and sculptural work, Sierra employs poor and desperate workers to fulfil specific work tasks in a given period of time for an agreed rate of pay. Because of this, his work is often accused of being exploitative. Alternatively, one could say it is a form of capitalist realism.

Sierra uses performances to challenge the ethical premise of art production and makes visible the economic inequities that facilitate his events. His work reveals that labour power is already a commodity, one that can be bought and controlled to perform almost any act.

In a key work from 1998, *Line of 30cm Tattooed on a Remunerated Person*, he persuaded a man, who neither had nor wanted to have any tattoos, to have a line tattooed on his back for fifty dollars. Sierra's art entails a more

malign variant of avant-garde strategies from the late 1960s and early 1970s. The tattooed line could be seen to cite the use of simple geometric markings in the landscape in the work of such an artist as Richard Long. Or closer to the mark, Dennis Oppenheim's *Reading Position For a Second Degree Burn*, 1970, in which the artist lay on a Long Island beach in the sun for five hours, with an open copy of a book entitled *Tactics* resting on his chest.[63] But there is an enormous difference between a mark made by someone choosing to walk through the countryside or deciding to submit their own body to sunburn in the cause of art, and the act of economic domination inflicted by Sierra over another person. What is significant and shocking about the work has nothing to do with the actual configuration of the graphic mark, but the indelible imprint of the social act that enables it. It abruptly and succinctly asserts that in a raw market economy where those with the means to buy transact with those who are forced to sell, anything can become a commodity.

Minimalism is a consistent point of critical reference for Sierra. In *Workers Who Cannot be Paid, Remunerated to Remain Inside Cardboard Boxes*, 1999, he adapts the formal conventions of Minimalism – the use of industrial materials and the serial repetition of modular units – by placing eight large cardboard boxes, spaced at equal distances apart, on the floor of a half empty office block in Guatemala City. Inside each of the boxes, Sierra paid eight workers approximately $9 to sit for four hours, unseen by the viewing public.

Sierra is careful to reconnect many of the formal and procedural characteristics of Minimalism with the wider industrial context from which they originally came and describes himself as a 'minimalist with a guilt complex'.[64] Sierra is nonetheless critical of Minimalism for 'formulating entities lacking any representative charge, devoid of anecdote', and accusing it of becoming 'aloof to everything else, supremely haughty... by setting immanence above necessity'.[65]

Part of the 'representative charge' that accompanies Sierra's work is achieved through his opening out of Minimalism's constructive methods to reconnect them with their industrial roots. So seriality, the standardisation of units and systematic organisation are understood not merely as aesthetic strategies but are conceptualised as being characteristic features of both Minimalism and capitalism. Sierra's willingness to acknowledge the political frame for his practice is clear and determines his conception of art, which for him is part of the cultural apparatus of capitalism and as such has a coercive function, not an emancipatory one. The force of Sierra's work is due in part to the way this role is overtly acknowledged and made a central feature of his projects, often resulting in the accusation that his art is exploitative. Sierra's audacity is to show to an art world that would maybe prefer not to see that 'very costly mechanisms of legitimation are involved in artistic creation, and there is no such thing as clean money.'[66]

Opposite – Santiago Sierra,
Line of 30cm Tattooed on a Remunerated Person, 1998.

[63] Oppenheim said of the piece, 'The body was placed in the position of recipient, exposed plane, a captive surface... I was tattooed by the sun.' 'Dennis Oppenheim Interviewed by Willoughby Sharp' in *Studio International*, London, 182, no. 938, November 1971, p. 188.
[64] 'I am also surprised by my own fascination for the minimalist object. At heart, I am minimalist with a guilt complex. Seldom have I seen more beautiful works than those by Judd, Le Witt or the first Morris. I subscribe to their maxim of "less is more", and their constructive methods are never far from my own. But I only use it as a toolbox – I'm talking about something else.' Interview with Santiago Sierra, quoted in *Santiago Sierra*, Spanish Pavilion, 50th Venice Biennale, 2003, p. 169.
[65] Ibid.
[66] Ibid., p. 175.

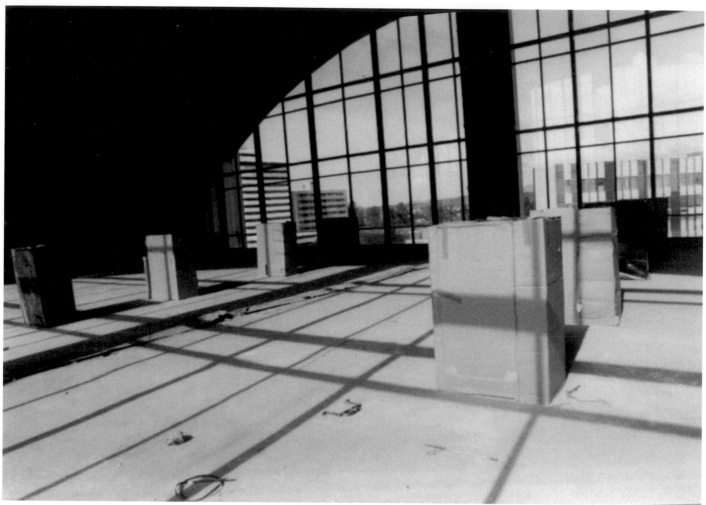

Above and opposite – Santiago Sierra, *Workers Who Cannot be Paid, Remunerated to Remain Inside Cardboard Boxes*, 1999.

Sierra's work knowingly abuses the fantasy of art production as unexploitational. What we encounter in his art is the real economic base of the avant-garde, capitalism's degradation. His work is bereft of the idea of art as redemptive and is infused with a tenacity to show power relationships that continue way beyond the gallery. The exploitation that Sierra is accused of administering in his employment of workers in his art is in fact the basic condition of existence for all workers in capitalism, and as such it is a given, a readymade state of affairs. For those who would prefer not to see this, Sierra's abuse resides in his eagerness to make a spectacle of such conditions and choreograph uncomfortable visualisations of such moments of exploitation to be consumed as art.

But it is a cheering fiction to delude oneself that exploitation does not attend the production of all commodities, including art.

As a commodity, art is subject to the same process by which surplus value is attained through the exploitation of labour power. Indeed, one could ask, apart from the fact that Sierra makes visible the social relations of production as part of the artwork, what real difference is there between his process of artistic realisation and, say, that of Donald Judd?

After all, both Judd and Sierra each hire industrial labour, both give detailed instruction to the workers to undertake specific tasks using industrial material and processes in an agreed period of time for a fixed wage, at the end of which the artwork is realised. Obviously the fundamental difference between Sierra and Judd is that Sierra prioritises the relations of production as a social process and renders this visible within the artwork, whereas for Judd this is unimportant and all that remains of the process is the fetishised art object.

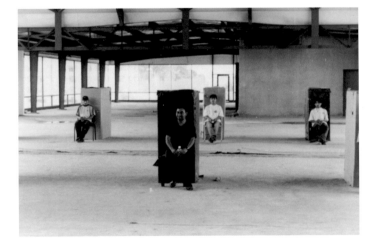

It is ironic that while Minimalism highlights the conditions of spectatorship of the art object, emphasising the status of the viewer as one who is embodied and whose experience exists through time and real space, it largely failed to present the embodiment of the workers involved in the production of the art objects. Sierra, in contrast, draws our attention to the process by which labour power is tasked and expended, revealing the power relationship within the cultural act.

While Minimalism sought to heighten the spectator's consciousness through an apprehension of the art object's external relationship to its physical and institutional location, Sierra directs attention toward the internal relations of the Minimalist form and the process by which it has come to be. In *Workers Who Cannot be Paid, Remunerated to Remain Inside Cardboard Boxes*, 1999, having literally filled the empty Minimalist form with real life, Sierra directs the spectator past the exterior of the cardboard box to imaginatively penetrate the relationship of the sculpture's interior space and contemplate the conditions of social subjugation held within.

The discomfort of the workers' actual containment and its recognition by the spectator disrupts the comfortable purity of the familiar avant-garde form — the Minimalist cube — and in so doing brings the viewer into a relationship with the specific economic realities of Sierra's art event. The abstract forms of avant-garde art collide with an awkward awareness of the exploitative and manipulative effects of capital. Sierra's forms are not just idealised geometric structures, they are soiled cardboard containers used to package commodities. What is so powerful about Sierra's work is that it provokes the spectator to conceptualise the normally invisible social relationship we have with commodities and comprehend the exploitation upon which they are dependent.

Many of Sierra's performances/sculptures involve the manipulation and displacement of industrial material. Often this will involve workers being paid to fulfil apparently pointless tasks, moving objects or materials around a space for a set period of time, contractually bound to put their labour power at the service of Sierra's will. In these circumstances the labour appears as a form of punishment, as little in the way of outcome is achieved other than the demonstration of Sierra's ability to control the actions of the workers. But from the workers' point of view there may be no real difference between the 'useless' tasks Sierra pays them to do and the work determined by any other boss. For the individual worker all that matters is that they get paid the going rate for their time. In *A Worker's Arm Passing Through the Ceiling of An Art Space from a Dwelling*, 2004, we see the labourer through the metonym of his arm. The arm is iconic of labour and Sierra seems to deliberately play with a history of photographic isolations and abstractions of the body as a sign for work. However, this arm is inert and the worker is paid to perform an act that incorporates redundancy.

Santiago Sierra, *Space Closed off by Corrugated Metal, Lisson Gallery, London,* September 2002.

Santiago Sierra, *Obstruction of a Freeway with a Truck's Trailer,*
Anillo Periferico Pur, Mexico City, Mexico. November 1998.

Displacement is not always used by Sierra as a sign of subjugation, compliance or a demonstration of capital's power; it can also be a sign of resistance and the winning of small, temporary victories. *Obstruction of a Freeway with a Truck's Trailer, Anillo Periferico Pur, Mexico City, Mexico*, November 1998 is an example of a project where Sierra engineers a temporary and symbolic halt to the flow of consumption. Having organised the loan of a heavy-duty truck, the artist instructed the driver to block the side lanes of one of Mexico City's busiest roads for five minutes by manoeuvring the truck's trailer across the freeway, and creating a traffic jam. Similarly in *Space Closed off by Corrugated Metal, Lisson Gallery, London*, September 2002, Sierra addressed his own commodity status when he blocked the entrance to the gallery for three weeks.

The challenge that Sierra's work poses for a liberal art audience is its succinct presentation as spectacle, the exploitative social relationships underpinning all commodity transactions.

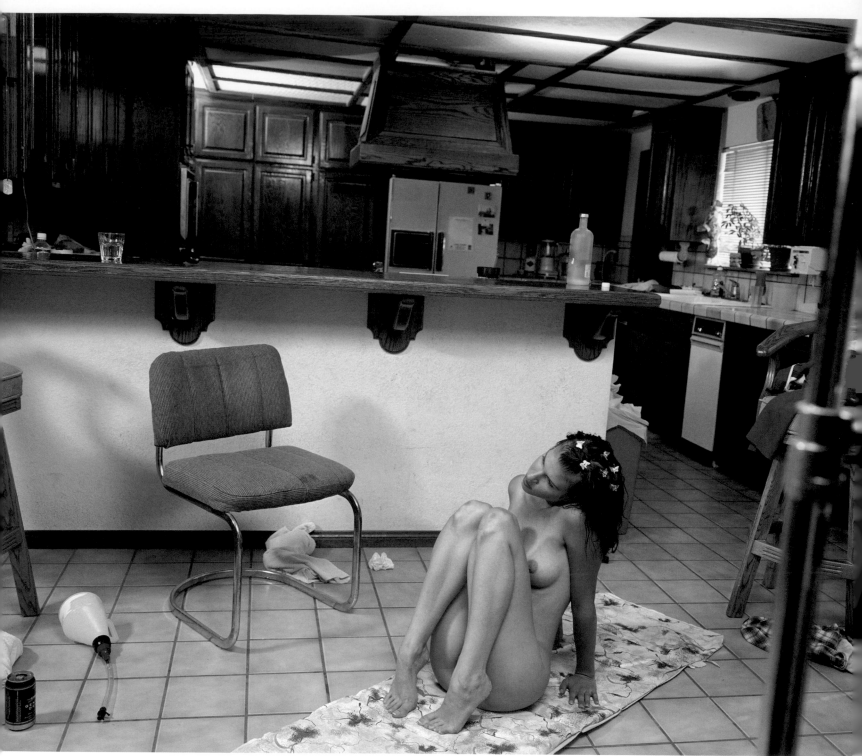

Larry Sultan, *Kitchen Floor, Reseda*, 2000.

Sex

Larry Sultan grew up in the San Fernando Valley, an affluent suburb of Los Angeles, home to middle-class families and approximately 80 per cent of the production of all adult films made in the USA.

The Valley started as a magazine assignment for a story 'A day in the life of a porn star' but it is as much about the fantasy of the great American dream and the ideal of middle-class domesticity as it is about porn.[67] While researching the project, Sultan noticed that adult film production companies seeking settings for pornographic films were renting middle-class homes in the area. The series of large scale, colour photographs continues Sultan's longstanding exploration of the myths of American family life, and examines why the fantasy of pornography is so at home in the setting of middle-class domesticity.

Sultan secured access to active film sets, photographing between takes and in rooms adjacent to where the porn was being filmed.

The photographs are lush, hijacking the seductive cinematic lighting of the set to reveal both the fantastic nature of the illusion and its mundane production. The series flicks between tangential images of beautiful entangled bodies delivering the filmic fantasy, to images of household commodities and actors and actresses in moments of repose, lounging amid the décor of the borrowed bourgeois home. The images speak of the glamour of the pornographic fantasy.

Like many artists engaged with commodity culture, Sultan's *Valley* photographs depend upon a strategy of appropriation. Not merely of a particular object, as is the case with Koons or Steinbach, but of a complete lifestyle. The homes used by the adult film companies and, by extension, Sultan are the homes of dentists and attorneys, whose taste, lifestyle and personal history are manifest in the décor of the houses. The film company does not simply hire architecture when they rent

a house as a setting for their films; they also borrow the material trace of its owner's lives.

The pornographic film is a commodification of desire as a filmic fantasy; similarly, the rented middle-class home, with its gaudy décor and excessive ornamentation, articulates another American fantasy, that of success, and its material manifestation through the accumulation and conspicuous display of commodities.

The Valley photographs flip between the depiction of both fantasies, revealing in the process their artifice and construction. They reveal the Valley, located close to LA, as a place embedded with the idea of stardom and happiness, a place where people have gone in the hope of changing and improving their lives. As Sultan describes: 'The Valley, too, has always been about fantasy. That's why you have Tudor homes next to Mediterranean ones, palm trees next to pines. It's about creating your own identity. The porn industry recognises the lure of this

fantasy-of-possibilities, it's part of the fantasy adult film consumers are looking for as well.'[68]

In Sultan's *Valley* images, the scenes of industrialised sex are repeatedly interrupted by distractions, his attention wanders and we are invited to scrutinise the mundane routine of porn's production amongst the banal paraphernalia of suburbia. Hard is rendered soft, peripheral and out of view, as Sultan inverts porn's core values and establishes a regime of visual titillation. In the pornographic world, sex is presented as a routine, compulsive activity occurring between a cast of regular folk, bored housewives, neighbours, cops, and deliverymen. The ordinariness of its location is seized upon by pornographers as a sign of its authenticity and as a means by which consumers can subscribe to the believability of the scenario and project their own desire on to it. The scenes of sexual frenzy often occur in spaces we recognise as part of our own domesticity: the kitchen, the garage,

[67] See Larry Sultan, *The Valley*, Zurich: Scalo, 2004.
[68] '*The Valley*: Larry Sultan Talks to Terri Whitlock', www.tfaoi.com/aa/4aa422.htm

Larry Sultan, *Hamner Drive*, 2002.

the back yard or living room. The frisson pornography seeks is born out of the friction between the ordinary and the extraordinary. A world of fantasy is apparently realised in the mundane reality of domestic clutter, a parallel world of desire occupies the same space as tins of beef stew, flat screen TVs and tapestry wall hangings.

Sultan's colour links with the mise-en-scène and the narrative spaces of the porn films; they are very much about the sets. They tap into the look of porn, embellish it and also show up its artifice. There also seems to be a critique of the pornography of décor in Sultan's series, the opulence of these full interior spaces. He does not show us the pornographic event, but instead lingers over the accumulations of interior décor, as a gaudy, vulgar show of excess.

In many of the images, the sex workers are depicted as yet another commodity awaiting consumption, sitting around between takes, often photographed next to food products that suggest their own refreshment as well as drawing a parallel with their own consumption as a sex worker.

In *Sharon Wild*, 2001, the artifice and excess of bourgeois décor and taste is unsettled by the specific vulnerability of the subject. Unusually, Sultan gives the porn star's name as the explicit title of the image, but in the context of an industry that trades in flesh, Sharon Wild is also a brand; a Czech porn star particularly known for her pale and slender physique.

Sultan's image of Wild shows her in a motel room, or the set of a motel room that, much as it might well serve as the setting for pornography, feeds a documentary reading. The grubby state of the mattress that is revealed at the edge of the image, providing an abject touch,

Larry Sultan, *Backyard, Film Set,* 2002.

089

Larry Sultan, *Den, Santa Clarita*, 2002.

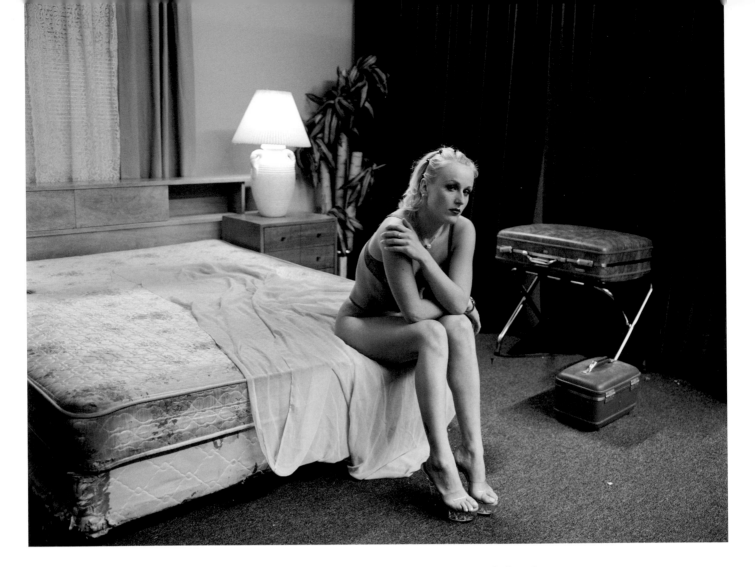

makes us think of the other, seedier side of the glam veneer of porn. Wild is perched on the edge of the mattress, effectively her place of work. She wears the trademark shoes of her profession, transparent high-heeled platforms that create the illusion of the model hovering inches above the floor, G-string, bra and heavy eye makeup. Sitting on the bed in a period of rest between takes, she remains guarded, her knees drawn together, her arms folded defensively across her chest. Near to her on the floor is a closed vanity case — one assumes containing the make-up necessary for her work — and behind it is a larger suitcase resting on a stand. Perhaps these are mere props for the set, but they also connote transience and the fluid existence a porn star leads, moving from one staged fantasy to another.

Sharon Wild, 2001 suggests that there is something beneath the postmodern veneer of the super lucrative porn industry, a revelation of the mundane, repetitious nature of the labour that underpins it; bodies that are becoming gradually worn out. This image might also be read as a gesture of quiet resistance by someone who knows the cost of looking at her body. This is not merely the passive victim of the sex industry but a worker who knows the value of her labour.

Larry Sultan, *Sharon Wild*, 2001.

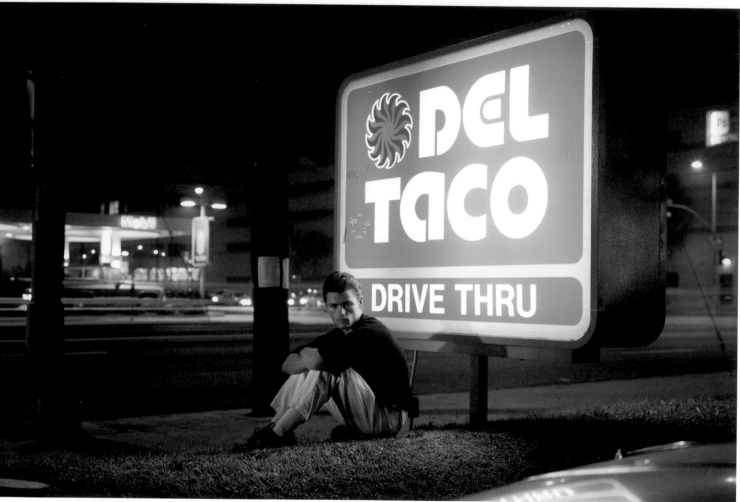

Philip-Lorca diCorcia, *Ralph Smith, 21 years old, Ft. Lauderdale, Florida; $25*, 1995.

Hollywood

Sultan's pictures relate to Philip-Lorca diCorcia's *Hollywood*, 1990-2 photographs.[69] Here too, documentary is embellished, given the gloss and veneer of commercial photography. It is as if something of the look Richard Prince highlighted through his rephotography of commercial photography, is now filtering and distorting documentary subject matter.

In many senses, diCorcia's *Hollywood* turns to the stock subject matter of traditional documentary. The difference concerns the way the work makes money and capital visible. The socialist reformist dream of traditional documentary has come under the spell of capital. He paid the people to pose for him, men he picked up on and near Santa Monica Boulevard, areas frequented by male prostitutes, drug addicts and drifters. diCorcia's disclosure of the monetary transaction between photographer and subject as part of each image's title, preceded by the subject's name, age and hometown, invites us to think of the documentary transaction as

another kind of prostitution, with subjects who can be bought like commodities. This analogy is also made through the fast food signs some of his subjects are positioned against and of course the overall commercial look of these stylised pictures, *Ralph Smith, 21 years old, Ft. Lauderdale, Florida; $25*, 1995.

The glow of capital mixed in with the ebbing sunlight gives aura and grace to diCorcia's otherwise 'low' subjects. While the lighting might also be seen to kindle the fantasies associated with Hollywood's dream factory, at the same time it adds a wistful, melancholic edge, accenting a sense of these people's transience, vulnerability and ethereality — they remain out of this world, detached, vacant.

In *Eddie Anderson, 21 years old; Houston, Texas; $20*, 1995, we see the young male, naked to the waist, through a diner window. His golden flesh is echoed in the bun of the uneaten burger in a tray on the counter, which is set between a jukebox and drink. Eddie

Anderson becomes fully part of this little still life display of cheap fast food and is presented as if in a shop window display. He might be looking in, but it is the viewer who becomes the ultimate window gazer here. The set-up and bored, blank look are reminiscent of Edouard Manet's paintings. Only if we read resistance in the inscrutable looks of Manet's figures — the look of the barmaid in *A Bar at the Folies-Bergère*, 1882 for example — the blank looks of Philip-Lorca diCorcia's subjects register compliance rather than defiance, and help to assimilate them into the commodified glossed-up worlds of his picture-tableaux.

[69] Peter Galassi, *Philip-Lorca diCorcia*, New York: The Museum of Modern Art, 1995.

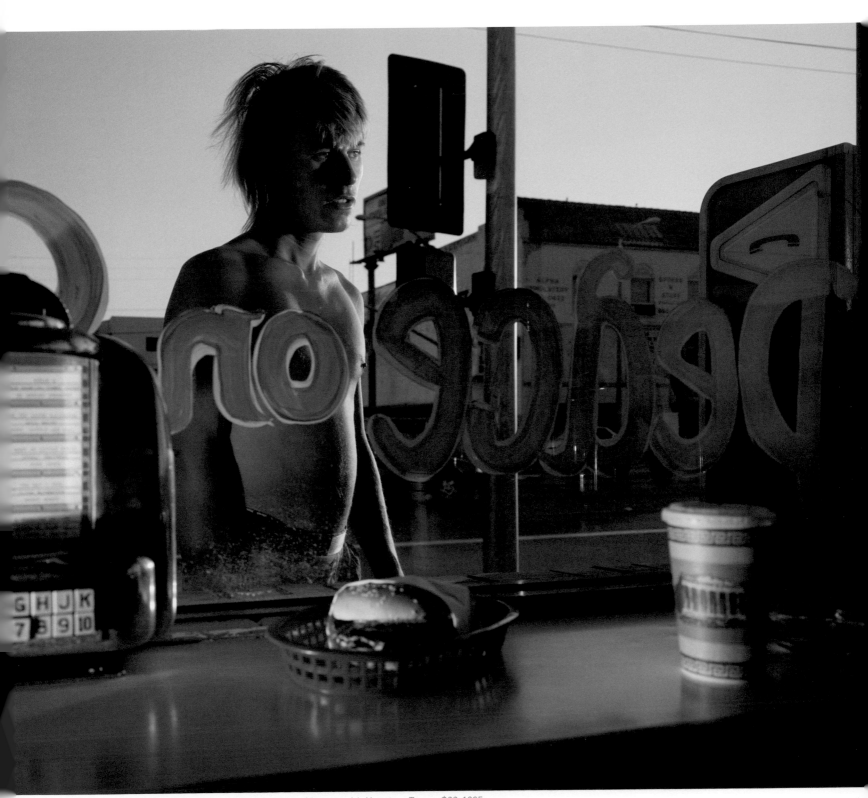

Philip-Lorca diCorcia, *Eddie Anderson, 21 years old; Houston, Texas; $20*, 1995.

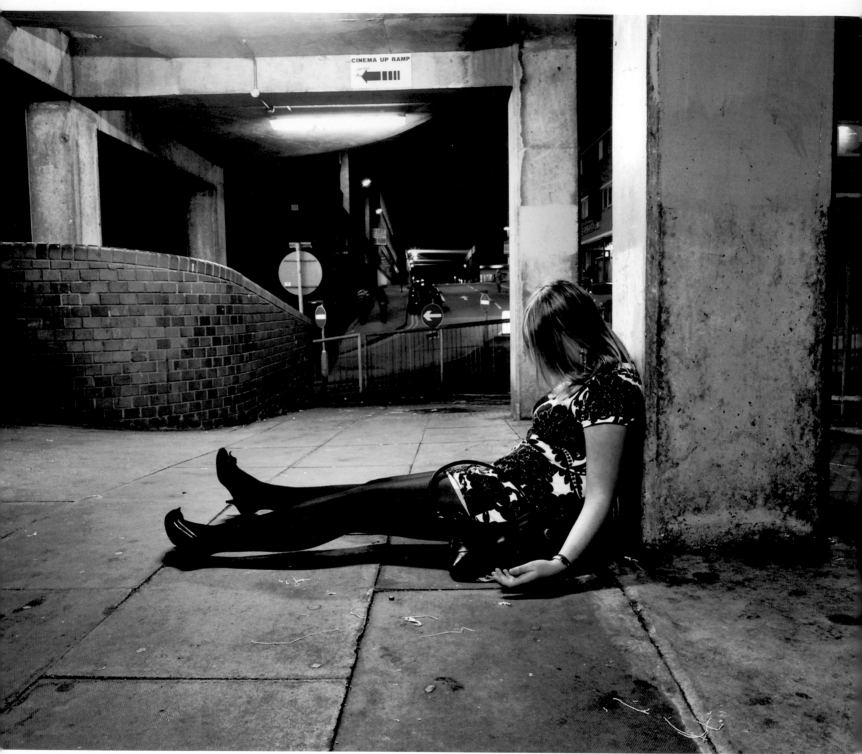

Common Culture, *Binge*, 2007.

Free Time

Philip-Lorca diCorcia's photographs rely on the rich connotations of twilight, that period of 'glow' that seems saturated with anticipation. Visually, twilight introduces the alluring façade of the city, the visual feast of artificial light creating seductive playgrounds in which to spend hard-earned time and money. The city at night lures us to consume its possibilities. Twilight suggests a slowing of pace from the toil of the working day, a shift into a different groove, one where we can take ownership of our 'free' time and spend it in the pursuit of pleasure. It also marks the transition of the city from a place of work to one more overtly dedicated to the pursuit of leisure and entertainment. Obviously the nocturnal city remains a site of labour and exploitation – workers in the entertainment and service industries are often the most poorly paid – but distracted revellers, the consumers of such labour, tend to overlook such work in the enjoyment of their own 'free' time.

Common Culture's *Binge* photographs, 2007, register the consequence of this self-induced excess, presenting intoxicated revellers, out of control and brought to a state of physical collapse. *Binge* documents the 'wasted' bodies to be found littering the streets of Britain's towns and cities in the early hours of any weekend. These images insinuate an analogous relationship between the visible signs of individual intoxication and the excess, exploitation and damage created by a society addicted to over-consumption.

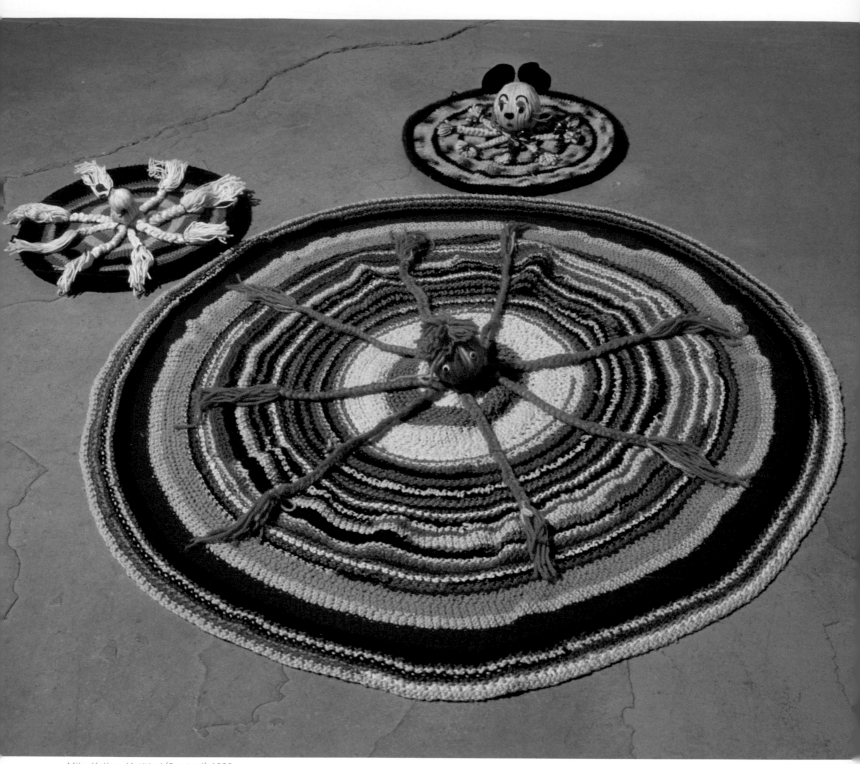

Mike Kelley, *Untitled (3 octopi)*, 1990.

Craft

Mike Kelley's use of craft objects becomes of significance in relation to the exchange of commodities and labour.[70] The stuffed toy animals, afghans and rugs are objects constructed solely to be given away. Such tokens of unsung, labour-intensive investments of craft were for Kelley a retort to the seduction of the mass-produced commodity, central to Neo-Geo art.

The toys register a different and more complex temporality. They both signal the hours of love committed by the maker to the crafting of the toy before its exchange as a gift, and evidence the period of use by its recipient. The battered and forlorn appearance of many of the toys employed by Kelley speak of this cherished and often abused use.

The nature of the labour deployed in the making of the toy is foregrounded in Kelley's work. Obviously hand-made, using thrift materials, scraps of fabric, odd buttons etc., the toys demonstrate the maker's investment of time and love, rather than time and money. Recognition of this investment is important; it determines how the object is valued and the status it is given. The toy's hand-made quality, traced through the signs of craft, may lack the glamour or aura of the mass-produced commodity, but achieves a form of compensation from the value it is able to accrue as a result of the unique *social* relationship existing between its maker and the person who receives it. To even describe this value as a compensation registers the sense of inadequacy often associated with the hand-crafted in cultures of mass consumption, where it is seen as a signifier of poverty or an inability to fully attain the status of what is considered to be a 'proper' commodity. Because hand-made toys evidence the social relationships embodied in the production, exchange and use of the commodity, they highlight the very relationship between people that 'proper' commodities deny.

Kelley's displays of grungy, battered and pathetic craft objects function as a counterpoint to the enshelved commodities in the art of Haim Steinbach. Steinbach's deployment of 'ideal' new commodities is unsullied by the demands of use. In other words, the objects he uses are those prior to their consumption, or more complexly, in a state in which their use has been deferred. The shelf life of the commodity is perpetually extended in Steinbach's art. Like Richard Prince, his art appears to stop obsolescence, fixing and heightening the spell and the moment of seduction, the deceptive aura of the commodity.

The conventions of commodity exchange and value are disrupted by Kelley's emotionally freighted objects. His work reinstates the commodity as an embodiment of social relationships, between maker and receiver, expanding the notion of exchange value to incorporate the concept of use and the economy of the gift.

[70] See John C. Welchman's survey essay, 'The Mike Kelleys' in *Mike Kelley*, London: Phaidon, 1999.

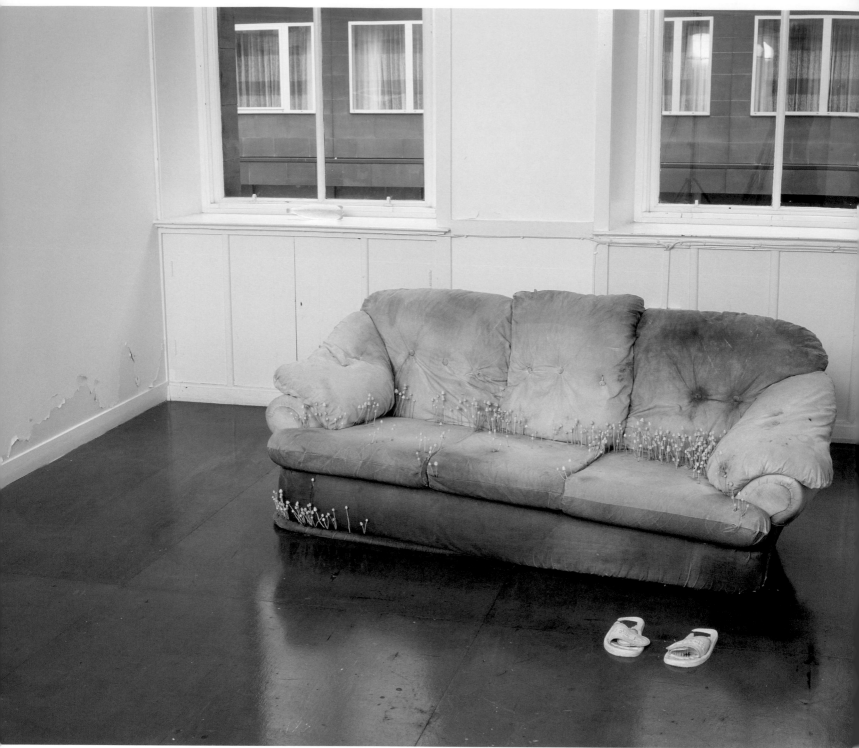

Richard Hughes, *After the Summer of Like*, 2005.

Thrift

Kelley's recourse to craft objects as a counterpoint to Neo-Geo commodity sculpture cues the engagement with what might best be described as a thrift environment by a number of younger contemporary practitioners. Their work shows us the descent of the commodity from the idealised, super-desired 'new' commodity in all its seductive glory to its decline and inevitable descent towards rubbish.

Many of Richard Hughes' objects simulate commodities at the end of their life: domestic furniture and furnishings in a state of seeping degradation, objects evicted from the dry world of domestic comfort and abandoned instead to the harsh sodden climate of the street. Hughes' sculptures speak of a culture of objects slumping toward disintegration and the inevitable encroachment of natural decay.

The objects he uses, like sofas and mattresses, are reminiscent of those dumped on urban waste-ground and back streets. In *After the Summer of Like*, 2005, an old sagging sofa, its upholstery stained and tatty, sprouts what look like magic mushrooms. It hints at the provisional sense of home afforded by the kind of battered furniture landlords provide for furnished student flats, a knackered object, only barely fulfilling its function as a sofa. To this extent, Hughes' work is reminiscent of Claes Oldenburg's Pop sculpture, where familiar domestic objects are made strange by shifts in scale or rendered from unusual materials that compromise the object's original function. In Oldenburg's *Giant Soft Drum Set*, 1967, we recognise the object as having the appearance of a drum kit, but understand that its functionality as a drum kit has been made impossible by its being made from soft vinyl and stuffed with polystyrene chips.

Hughes' modifications register the journey that all commodities make: in the case of the sofa in *After the Summer of Like*, 2005, the descent from a state of plush newness, showcased in department stores and tidy front rooms, to worn out junk on its way to the rubbish tip. Crucially, this state of decline is signalled through the implied intervention of dampness, suggested by the growth of fungi sprouting from the body of the object. The implication is that the object has either been cast out from the comfort of a home to suffer the ravages of the external elements, or has languished in an impoverished interior or, worst of all, has soaked up the bodily seepage of its previous owners.

Despite their dilapidated condition, many of Hughes' objects suggest a use value distinct from that originally intended. In *After the Summer of Like*, 2005, the combination of the trippy title and the crop of mushrooms emerging from the sofa suggest that the battered furniture has become a site for hallucinogenic transformation.

This and other objects speak of a surplus existence, shorn of domestic usefulness, too far gone or too dated even for the charity shop. They bring to mind the marginal locations inhabited by children and teenagers, those dead-end spaces where bored youth meet up to have a drink and get up to pranks, hidden from the prying eyes of adults. Often such spaces are marked by the accumulation of discarded household goods, fashioned into makeshift 'dens', places where youthful *bricoleurs* assert their independence and identity out of the ruined commodities of the adult world.

Hughes' relationship to commodities emphasises their status as objects of use, indeed over-use, exhausted products out of fashion and long past their prime. But there is something about their very datedness that makes them so rich in association, prompting the viewer to recall when and where they might have seen them before. The specificity of the objects used by Hughes would seem to privilege viewers who might share his British working-class background, growing up during the late 1970s and 1980s on the outer fringes of a city. The ordinariness of this experience is reflected in the

range of objects Hughes carefully fabricates: everyday commodities from plastic drink bottles, trainers, bin-bags to domestic furniture.

Hughes has spoken about the satisfaction he obtains from meticulously hand crafting objects that look as though they've just been found, as though they could have been readymades dragged in from the street. His simulated objects demonstrate a hobbyist commitment to craft skill, in contrast to an artist like Haim Steinbach who

deploys the skills of a discerning shopper in his choice and arrangement of existing commodities. With Hughes the relationship with the object is physical, intimate and meticulous; his symbolic objects are laboriously constructed through a dextrous engagement with raw sculptural material. There is a geeky showmanship to the craft skills embedded in his simulated objects, but there is also a real sense of understated sincerity in his fabrications, since these objects matter to him.

Hughes' sculptures look like familiar objects, things he is at home with, perhaps even carrying the charge of autobiographic reference. There is nothing deliberately shocking or provocative about the objects he fashions as art. Even in a work like *Roadsider (First of the Morning)*, 2005, where Hughes has carefully simulated in resin a bottle of piss, suggesting a minor dramatic incident involving a driver with a need to urinate, a certain polite protocol is observed. At least the bottling of the urine implies the desire

to tidy up the act of bodily release, and Hughes' display of the object within the gallery mimics the surreptitious dropping of the original item in a discreet location.

The inconspicuous nature of many of his sculptures, such as *Untitled (Match)*, 2003, suggests that Hughes is interested in catching viewers unaware, surprising them with his sculpture when their cultural guard is down, forcing a sudden confrontation with his work. Often works are given titles that trade on

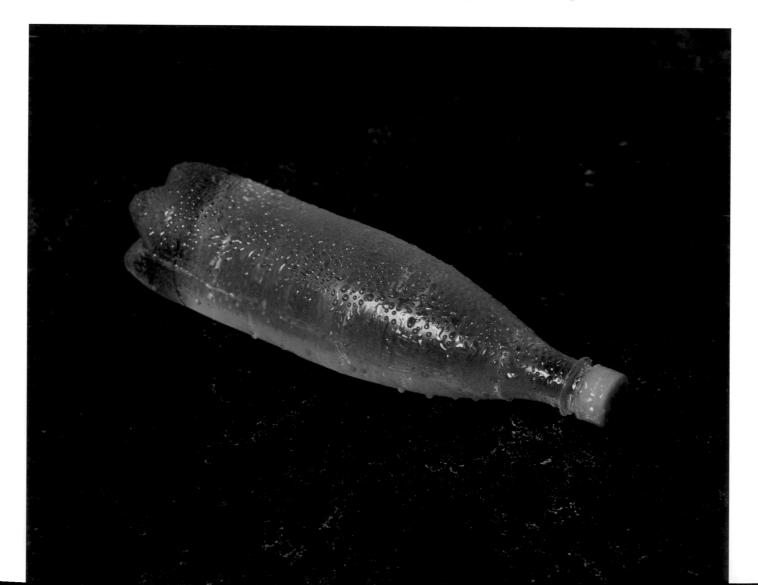

Richard Hughes, *Untitled (Match)*, 2003.

Opposite – Richard Hughes, *Roadsider (First of the Morning)*, 2005.

subcultural recognition, references to music and comics and despite their often discreet physical presence, Hughes' sculptures are able to evoke a powerful sense of recognition, tripping memory flashes. The experience of his work often feels like a series of Proustian rushes.

In *Untitled (Match)*, 2003, the head of a solitary, almost extinguished match perpetually glows as it overhangs an empty shelf. The effect is to intimate human presence and the viewer begins to narrate his or her own account for the little drama.

Often Hughes painstakingly constructs objects that look wasted, forlorn, dejected, but also replete with jokes and witty comments on social behaviour and the recent past. The discarded objects are marked by their use and often carry a trace of their user's bodily waste. This gives his objects pathos; these commodities are not cut off from us, but anthropomorphic, they are given a human value and connection.

Unlike Steinbach and Koons, Hughes is not enamoured by the shiny surfaces and seductive allure of the new, ideal commodity. His work articulates a relationship with commodities based on use and intimacy; the objects carry the trace of a process of specific human contact, they are often grubby and tainted but are more evocative of the complexity of our relationship to commodities than the mere bearer of sign value.

Brian Ulrich's large-format, frontal photographs of thrift store interiors present us with displays of remaindered objects. As photographs they become still lifes, a vanitas of objects past their best, bereft of the shine and gloss of the new. Here is the grungy, grubby, worn and melancholic counterpoint to the hyperreal displays of new merchandise. Ulrich's pictures show abandoned objects, accumulating in the kind of abandoned retail spaces that can be found in the run-down areas of most towns and cities. Still spaces, tainted by failure and the smell of neglect, their very presence serving to

Brian Ulrich, *Chicago IL 2005 (Toys)*, 2005 and *Untitled Thrift, 2006 (Shoe Pile)*, 2006.

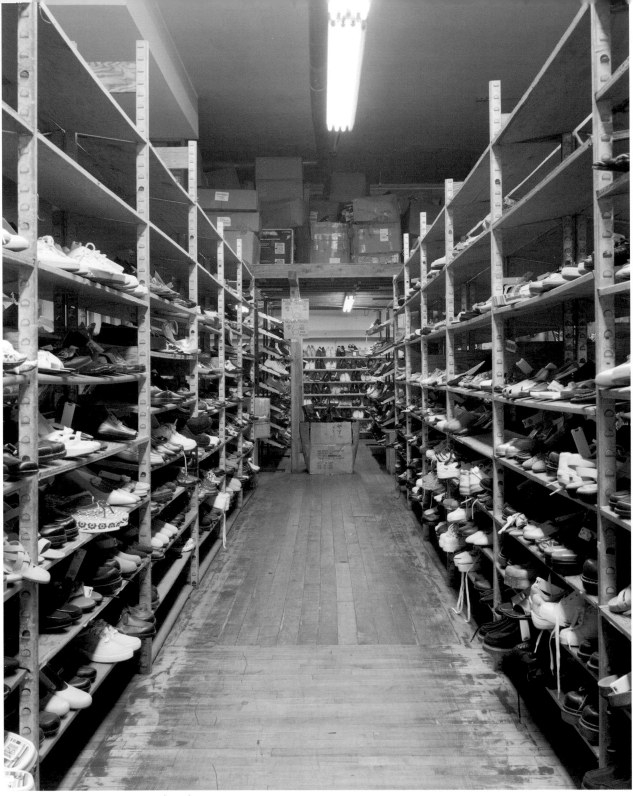

Brian Ulrich, *Untitled Thrift, 2006 (Aisle)*, 2006.

Overleaf – Brian Ulrich, *Untitled Thrift, 2006, (Vhs)*, 2006
and Chicago IL 2005 (Toys), 2005.

confirm the marginality of the economic activity of the area in which they are sited. The flow of capital and the rapid circulation of desired commodities take place somewhere else. Movement slows to an almost funereal pace in thrift stores.
A confused temporality permeates their fluorescent-lit interiors; the commodities of the future, or even the present, are not to be found here, only the debris of an ever-expanding past. Objects lose their place in time, severed from their anonymous owners. Any sense of logical relationship between commodities is lost: their presentation, or more accurately their accumulation, stages pathetic affiliations, objects grouped together in terms of size, categories of use or the ease with which they can be stored. Stripped of any promotional sales-pitch to stimulate consumer desire, the commodities of the thrift shop exist in a kind of commodity half-life, waiting for a second chance, only temporarily staving off the inevitability of their journey to the rubbish tip.

Ulrich's pictures display both excess (the surfeit of trainers, seconds one assumes or

brands that will never be in fashion, literally spilling out of boxes) and depletion (the empty racks of transparent plastic coat hangers).

Andreas Gursky's photographic spectacles of consumer goods, trendy trainers, posh Prada wear, are in many respects the obverse of Ulrich's. Gursky's images are often digitally embellished to amplify their spectacular effect. There is little slippage or dirt; his pictures often appear too clean and seamless. Gursky embraces and magnifies the process of commodification through photography. He addresses the spectacle of consumerism, but maintains through the sheer monumental scale and presence of his pictures a formal discipline of composition, which in many senses could be seen as a hankering after a Modernist formal order.

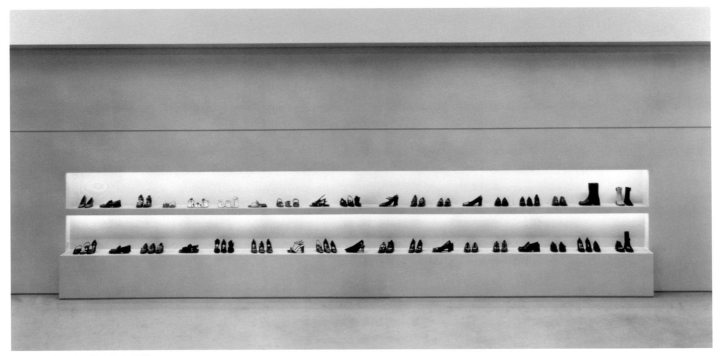

Andreas Gursky, *Prada I*, 1996.

Opposite – Brian Ulrich, *Madison, WI 2005 (Hangers)*, 2005.

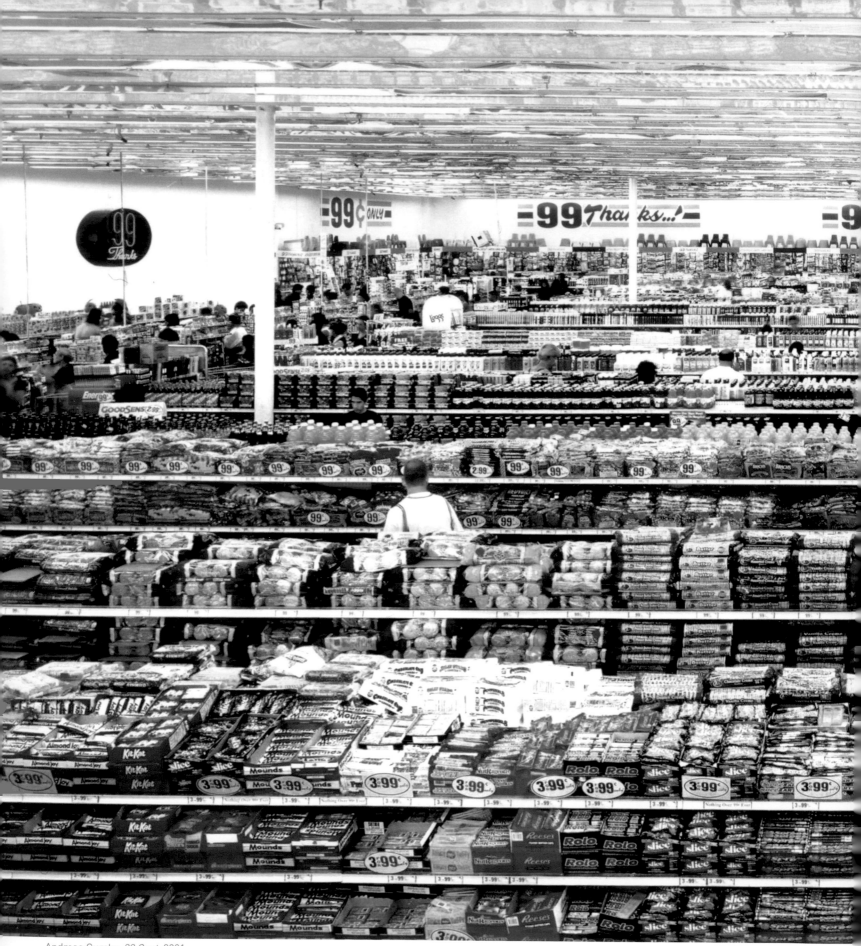

Andreas Gursky, *99 Cent*, 2001.

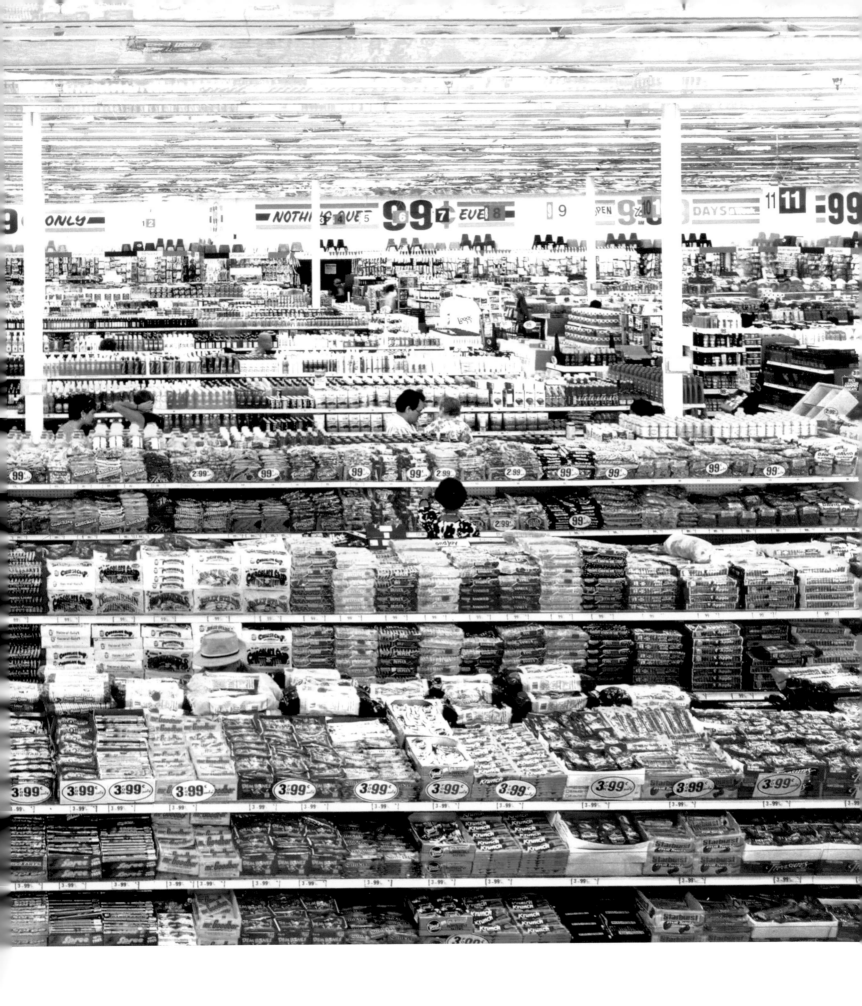

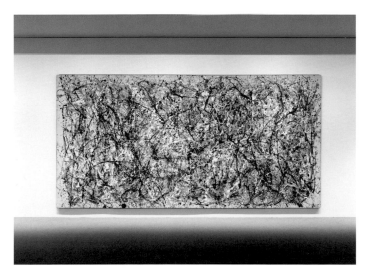

Andreas Gursky, *Ohne Titel VI*, 1997.

Ulrich's pictures are much more modest and understated. When Gursky pays homage to Pollock and Turner in his pictures of art in museums, one senses that he is inviting us to see formal correspondences and links with his own pictures, as critics have gone on to do, *Untitled VI*, 1997. Ulrich simply depicts the jumbled collections of tatty kitsch pictures. And when his photographs give us something of the sexy glamour of stardom, it is the glance of pop singer Britney Spears whose 15 minutes of fame are over: her life-like picture now adorning a dented display stand, left at the back of a container lorry.

Opposite – Brian Ulrich, *Untitled Thrift*, 2006 *(Britney)*, 2006.

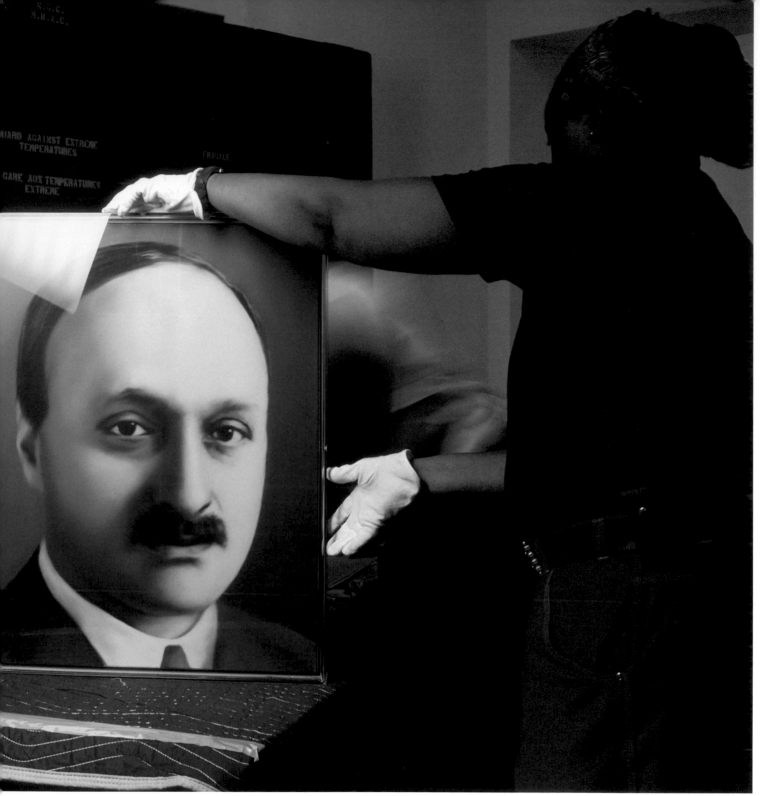

Louise Lawler, *White Gloves* 2002/04.

114

Display

Louise Lawler photographs the display of artworks in private collections, being sold off at auction houses, or in the museum. In her museum[71] photographs, she is especially attentive to the sites of storage and the differing and unexpected relationships that can be found between art objects, behind the scenes of their public and sanctioned display.[72] On occasion she will show us a gallery worker. In *White Gloves*, 2002/04, for example, the subject's presence, in a telling power relationship, is secondary to the artwork they are holding. We do not see their face. The title associationally alerts us to the ethnicity of the art handler. And that the artwork is a Richter photorealist copy of a formal male portrait makes us think about particular patriarchal values and relations that underpin investments in art.

Lawler's work emerged in the 1980s, amidst the booming USA economy and the ensuing consumer orgy, where art was money. Framed within the discourses of Postmodernism, her work was seen as critical of metaphysical and transcendental ideas of art's value. She showed up the reality that art was simply a form of luxurious décor and economic investment. Her photography was less concerned with the properties of art than with art as property.[73]

In Lawler's identical pictures of Warhol's Marilyn gold tondo, with its rather glossy varnish and valued, as the auction-house label that accompanies it shows, between $300,000 and $400,000, Lawler gives us two titles as questions: *Does Andy Warhol Make You Cry?*, *Does Marilyn Monroe Make You Cry?*. The questions imply that what might move us to tears is not the art but the artist or the subject of the art, which in this case is connected with the celebrity status of Warhol and Marilyn. In other words her photographs seem to be speaking of something that is lost in this star-struck process of affective art response. Of course there is an irony here, because her work is notable for the absence of its author, or rather tends to be theoretically framed in this way. What her pictures show us is not only other artists' art but also other people's arrangements of art.

[71] See Louise Lawler, *Twice Untitled and Other Pictures (looking back)*, Cambridge MA: MIT Press, 2006; Jack Bankowsky, *Louise Lawler and Others*, Germany: Hatje Cantz, 2004.

[72] To some extent there is a shared realm of interest with Ashley Bickerton's sculpture. Though formally very different, their work both registers the status of art as a luxurious commodity that is stored, transported and exhibited.

[73] Craig Owens describes the work of Hans Haacke in this way, but it is equally appropriate as a description of Lawler's work. See his essay, 'From Work to Frame, or, Is There Life After "The Death of the Author"' in *Beyond Recognition*, Berkeley, LA and Oxford: University of California Press, 1992.

Louise Lawler, *Does Andy Warhol Make You Cry?*, 1988.

Louise Lawler, *Does Marilyn Monroe Make You Cry?*, 1988.

Louise Lawler, *Pollock and Tureen*, 1984.

And these arrangements can set up quite amusing jokes about taste and value, at the expense of Modernism. In Lawler's *Pollock and Tureen*, 1984, Pollock's drips are brought into uneasy proximity with the decorative flourishes on a sideboard ornament. Lavish and expensive as the tureen might be, the autonomy of Pollock's work is upset by such a close correspondence.

Lawler's photographs reflect upon the dispersal of art as commodities and décor. At the same time, they maintain a certain aesthetic of their own. They are not anti-aesthetic, but maintain a certain faith in photography's distinctive aesthetic values, through their cropping and composition and the formal correspondences and contrasts this sets up. In *How Many Pictures*, 1989, this seems especially so. Here a Frank Stella Protractor painting glows in the reflective sheen of the gallery floor.

Such a formally enticing picture also speaks about the way Modernist abstraction comes under the sway of commodification, as Rosalind Krauss has suggested.[74] Stella's painting is transformed into an evanescent rainbow. This seems to cue Lawler's use of the paperweight miniatures, in which she repackages her own photographs as ornaments. Such glass miniatures allude to the ceaseless dispersal of art as kitsch spectacle through reproduction, abruptly colliding her measured and knowing photographs of the display of art with the tacky world of simulacra culture. Displayed on pedestals, these colourful glass domes are nevertheless presented as refined and exquisite objects — Lawler's commodification of her own art is not entirely bereft of aura.

[74] See Rosalind Krauss's essay 'Louise Lawler: Souvenir Memories' in *Bachelors*, Cambridge MA: MIT Press, 1999.

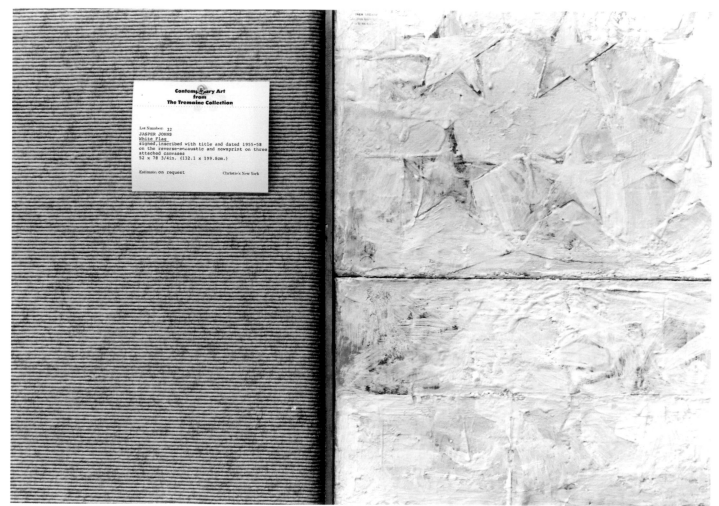

Louise Lawler, *Board of Directors*, 1989.

Louise Lawler, *Monogram*, 1984.

Wang Qingsong, *Vagabond*, 2004.

Excess

Chinese artist, Wang Qingsong's earlier use of photography was allied with the garish colours of what was termed Gaudy Art, a movement that held an ironic relation to the Maoist policy on the arts — intended for a peasant audience, where bright colours pervaded Communist works of art.[75] Qingsong continues this aesthetic but instead of the Communist realist iconography of happy workers, soldiers and peasants, he presents us with scenes of pleasure and hedonism, in which the allure and seduction of commodities is allied with female bodies, a variant on the sexism of much western advertising. He turns Maoist iconography into the kitsch iconography of consumerism. An early work, *Our Life is Sweeter than Honey*, 1997, actually used the image of angelic children from popular Chinese New Year posters. Qingsong extends the optimism of Cultural Revolution propaganda posters ironically in relation to a worshipping of the commodity.

But subsequent work has seen a shift in the iconography and colour. *Vagabond*, 2004, and *Home*, 2004, for example, present us with states of waste and destruction. We shift from the garish colours and overt symbolism of an earlier work like *Thinker*, 1998, with its criticalcommentary about the worshipping of consumer goods, to work in which the shiny veneer of commodities has gone and we are left instead with states of ruin, breakdown and collapse.

In Wang Qingsong's *Home*, the demolition alludes to the destruction of old houses making way for new as part of China's rapid change. Here the ruins are filled with garbage, cultural waste, the only colour in this otherwise monochrome scene. In *Vagabond*, 2004, Qingsong plays the homeless person, lying with his female partner in a dark and grubby urban space, with Coca Cola and Fed-Ex packaging and newspapers as their bedding. Neither is fully clothed and the flash of skin amidst the litter gives a sexual frisson to the scenario, introducing an unexpected element to the familiar documentary pastiche. This seems to muddle the conventions and introduce a jarring note. The familiar equation of sex and consumerism is given a new twist as the debris and waste of consumption accompanies this spent couple.

Qingsong includes himself in a lot of his work. This could be seen as an element of self-promotion and narcissism that echoes the way consumer culture is centred upon the individual. This becomes a brazen marketing of self within *Billboard*, 2004, which depicts a huge advertisement with ARTWORKS OF WANG QINGSONG in English and Chinese, the address of the artist's English-language website and a phone number. Figures are set before this promotional display; some seem involved in completing its installation while others mime everyday street activities. The detail of the fruit and vegetable sellers, who have set up store before this big banner, serves as a reminder of China's agrarian past, displaced by the crude and garish promotional and commercial strategies of capitalism.

Competition, 2004 presents the glut of advertising as a contemporary babel. Here an excess and surfeit of competing signage leads to breakdowns in communication. There is a sense of entropy, of energy run-down, depletion, which also marks his other works, *Vagabond* and *Home*. In *Competition*, giant walls are covered with hundreds of handwritten and hand-drawn signs, bearing the slogans and phrases of advertisements, from multinationals to small businesses. People are depicted competing and fighting for the optimal public placement of these ads. Qingsong has said that 'The struggle for ad placement in public space in China is not unlike a battlefield strewn with casualties after a pitched battle for power. Today one brand wins. The next day, its competitor will replace it with better positioning on public spaces. Every day, new ads go up, and old ones fall down, scattered in pieces, and discarded on the ground under newly erected billboard advertisements.'[76] In this respect *Competition* extends Qingsong's earlier series

[75] www.wangqingsong.com
[76] Ibid.,

Wang Qingsong, *Home*, 2004.

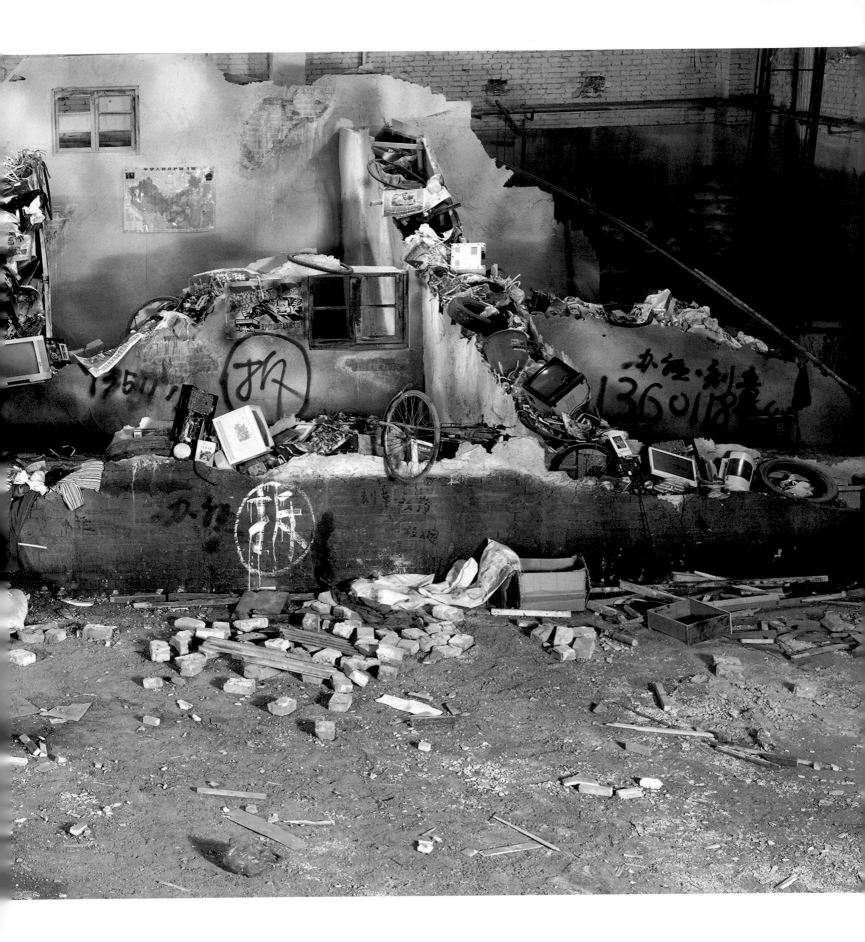

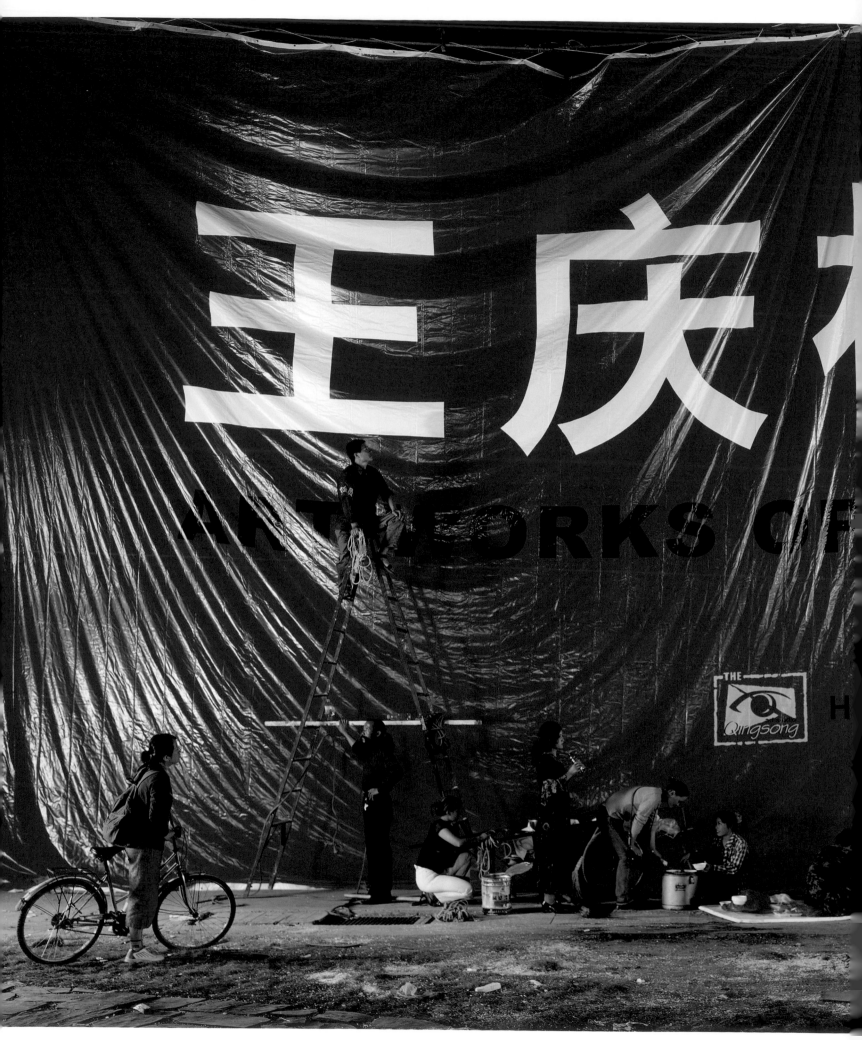

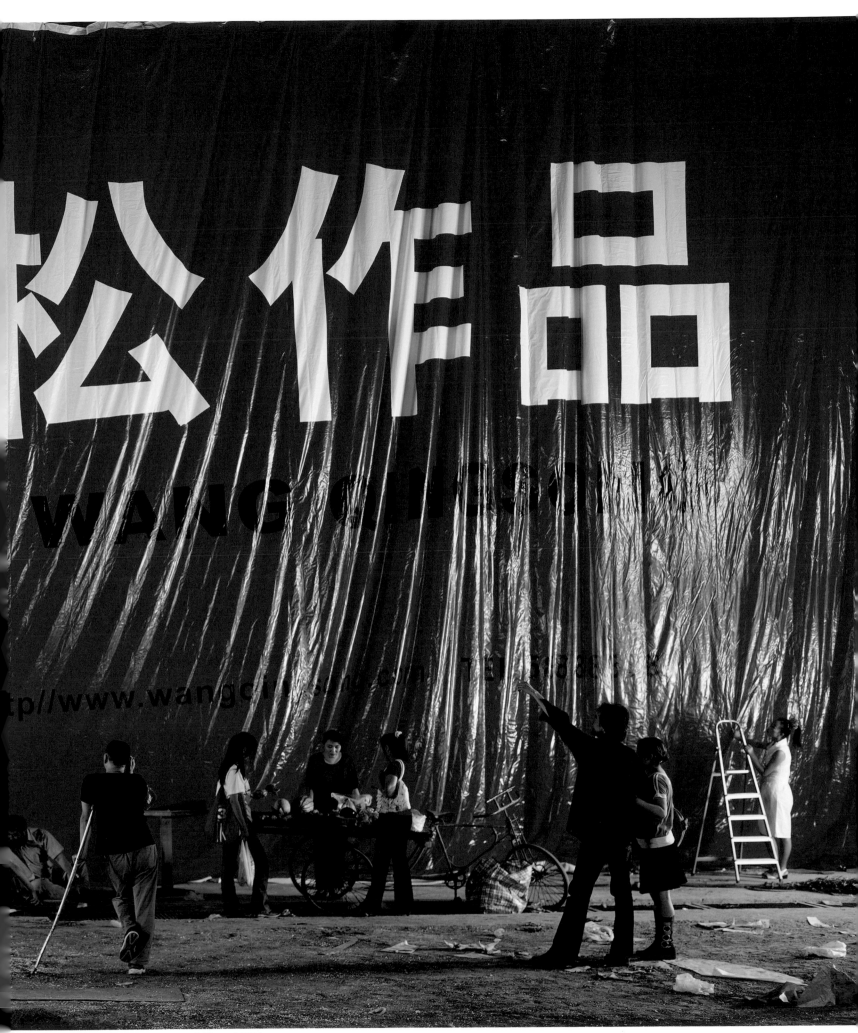

Wang Qingsong, *Billboard*, 2004.

Another Battle, 2001, in which he mockingly played a wounded commander defeated by Western capitalism, symbolised by the logos of the multinationals, McDonald's and Coca-Cola.

The 'outdoor advertising onslaught' of *Competition* mirrors the propaganda under Communism. Much as it comments upon present China it also recalls the past. As Qingsong says, the advertising is 'not unlike the big character posters ("Da zi bao")[77] posted by competing factions and littering city streets in China during the Cultural Revolution. In the past the streets were hung with posters in fights over political beliefs. Now the struggle is over financial power and business gain.'

Qingsong seems to exhaust the mechanics of advertising, mixing the new face of

capitalism and its glut of marketing signage with the former propagandistic strategies of communism. When he hoists his own advertising banner to promote himself, it is of course red. In many respects his art mirrors the correspondences and collisions existing within a culture caught between two crude forms of propaganda: communism and capitalism. The very hyperbolic forms of his constructed scenarios are a necessary exaggeration, the overstatement and excess proceeding from a need to try and secure a voice and position in a culture teeming with signs. The crudity of the language, the collisions between the Old and New faces of China, the narcissistic and hedonistic characteristics of his work, all are redolent of a crisis and anxiety about the distinction and value of art in relation to hegemonic systems.

Wang Qingsong, *Competition*, 2004.

[77] Ibid,. The 'Da zi bao' posters were handwritten accusations that targeted and condemned citizens of what were defined as the 'Five Black Categories': landlords, rich farmers, counter-revolutionaries, rightists and criminals.

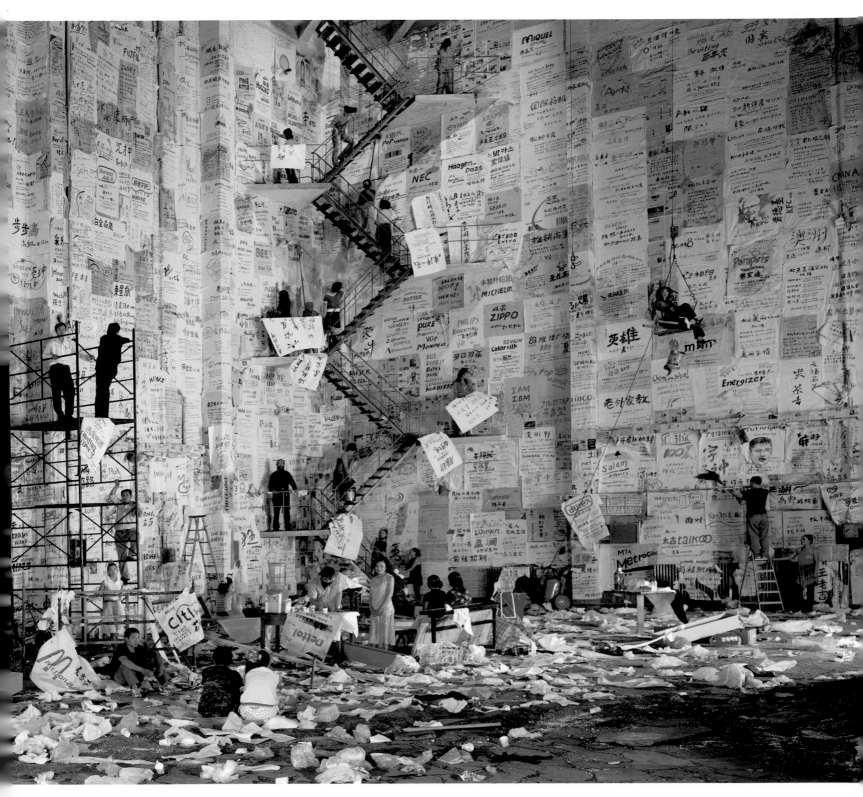

Edward Burtynsky, *China Recycling #8, Plastic Toy Parts, Guiyu, Guangdong Province*, 2004.

Recycling

Photography as a medium of spectacle and allure embellishes consumer culture. Artists like Richard Prince and Louise Lawler showed us this very process. Photography's aesthetic can capture very well the reflective sheen of the surfaces of capital's culture. Both their work intervenes at the surface of allure. Lawler reminds us of the crude relationship between money and art, a transaction that debases and counters her own clear fascination with the look and appeal of art on display, whether as a collector's decorative ornament or up for sale in the auction room. Prince's re-photography of advertisements, much as it is clearly seduced and captivated by their spell, nevertheless also exposes their artifice and fakery.

The Canadian photographer Edward Burtynsky makes visible the negative effects of global capitalism.[78] Behind his work lies a documentary imperative, to show us something of the real damaging consequences of consumerism. Yet as large-scale visual spectacles, his photographs maintain an aesthetic order and grace. His picturing of the depletion of natural resources or the pollution of the landscape comes replete with allusions to abstract paintings and modernist sculpture. Waste is aesthetically rehabilitated. In the two pictures that make up *Shipbreaking, Chittagong, Bangladesh*, 2000, the strange ruined landscape created by the deformed hulks of the dis-assembled ships resembles the forms of Richard Serra's monumental sculpture.

Among his recent photographs of China, a number show the country's trade in waste, from such corporate operations as Cankun, the world's third largest aluminium recycler, to more primitive electronic waste recycling. Ninety per cent of North America's offshore e-waste goes to China.

Burtynsky pictures the waste and excess of commodity culture. This is the cost of technological global development. Emerging economies like China are contracted to recycle the West's waste, becoming in the process the site of huge toxic dumping grounds. Burtynsky's large-scale photographs, depicting landscapes all but chocked by the debris of the West's consumerism, capture the excess and burden of the process. In *China Recycling #8, Plastic Toy Parts, Guiyu, Guangdong Province*, 2004, mounds of junked plastic toys smother the landscape, sprawling across the pictorial field. In another image, *China Recycling #9, Circuit Boards, Guiyu, Guangdong Province*, 2004, a tide of computer circuit boards flow toward the edge of a forest, vividly capturing the sense of encroachment. Here is an allegory of consumerism, drawn up in terms of a dis-equilibrium between culture and nature and between the West and emerging economies.

It is also evident in the shifting patterns of labour that have developed in such corrosive environments. Established agrarian traditions are abandoned for the lure of the quick profit to be gained by the recycling, albeit by hand, of the electronic waste.

In contrast to the spectacular panoramic displays of wasted commodities, Burtynsky also gives us detailed studies of the dirty and hazardous work of the recyclers, many of whom are farmers who have left their land for the more lucrative trade in e-waste, *China Recycling #12, Ewaste Sorting, Zeguo, Zhejiang Province*, 2004. In his detail showing this process, parts from obsolescent technology are shown being stripped by the simple tools of the salvager, in which workers vulnerable to the toxicity of the waste cook circuit boards to remove components, pour acid solutions over chips and burn wires to liberate the precious but toxic lead, cadmium and mercury.

[78] See Edward Burtynsky, *China*, Steidl Verlag, 2005.

Edward Burtynsky, *China Recycling #12, Ewaste Sorting, Zeguo, Zhejiang Province*, 2004.

Edward Burtynsky, *China Recycling #9, Circuit Boards, Guiyu, Guangdong Province*, 2004.

Overleaf – Edward Burtynsky, *China Recycling #24, Cankun Aluminum, Xiamen City, Fujian Province*, 2005

133

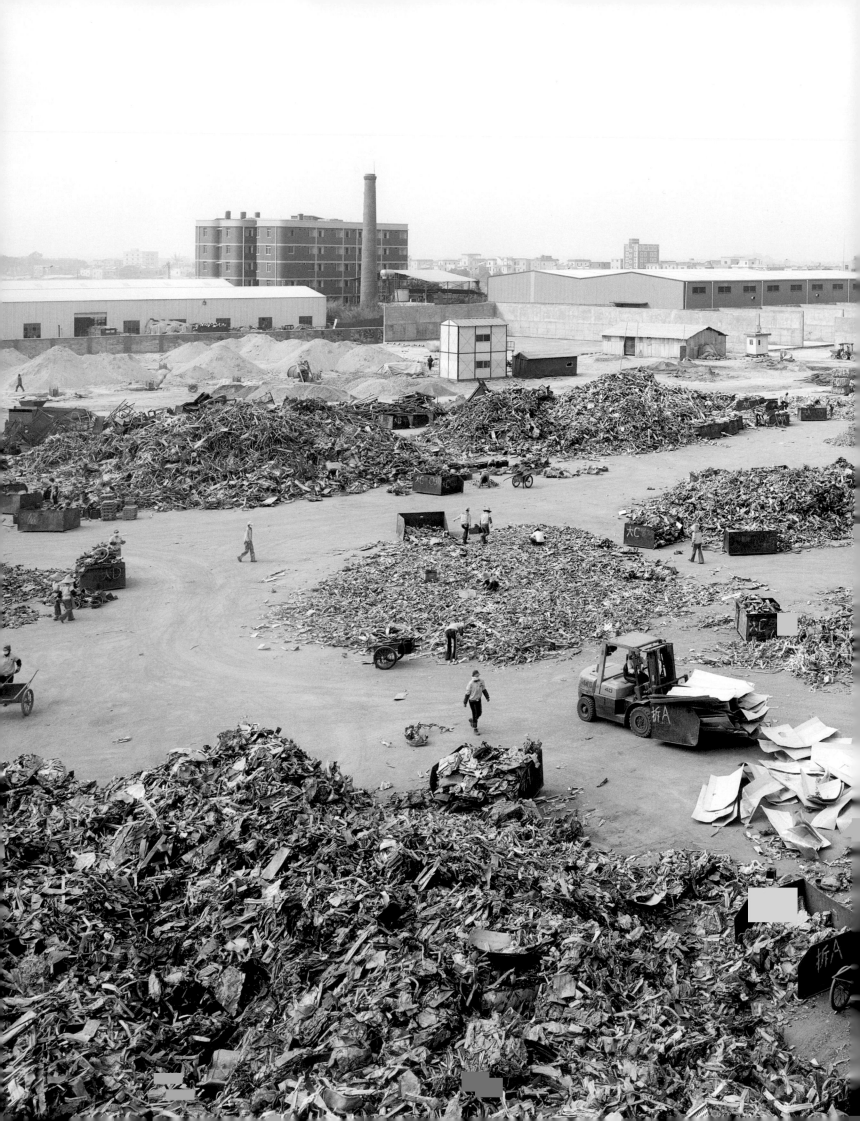

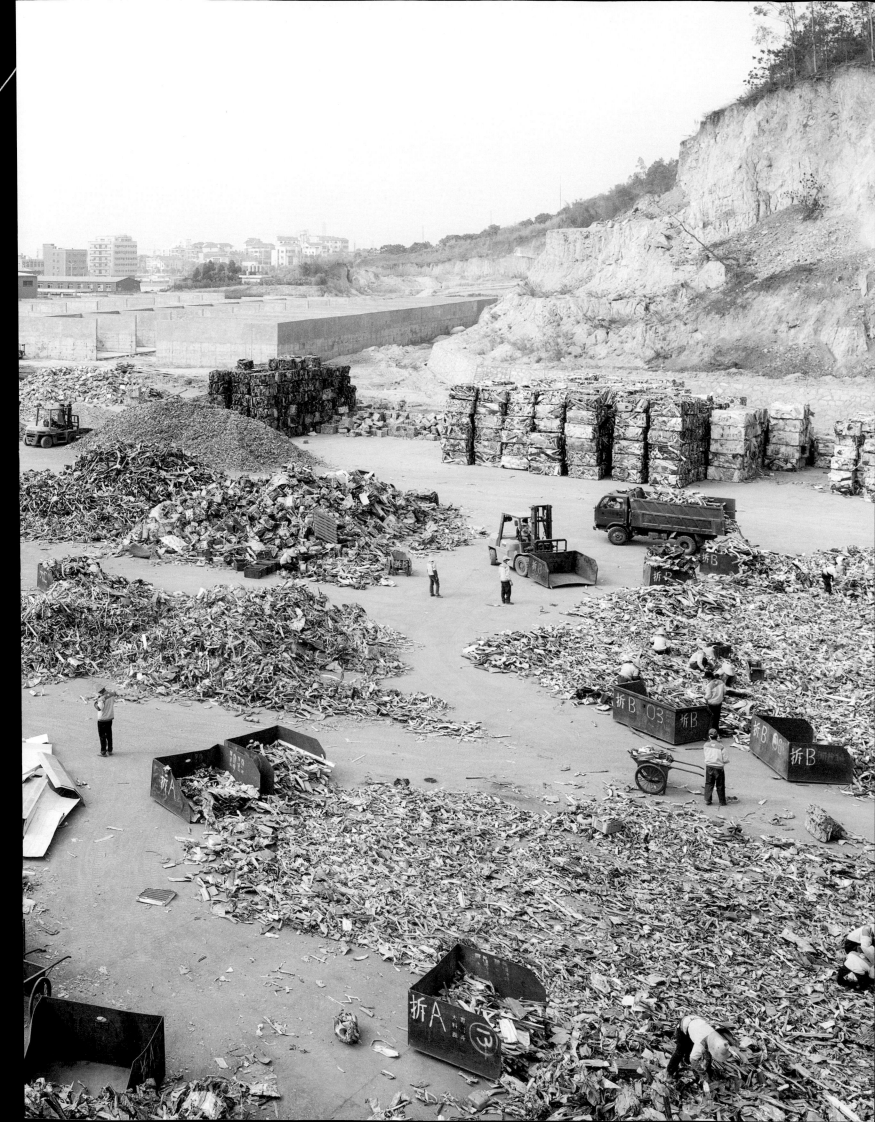

Melanie Jackson, *Made in China*, 2005.

Animation

Melanie Jackson's *Made in China*, 2005 video installation pivots on the relationship between two modes of labour and two stories of migration by young Chinese women. She presents them as linked but opposed, projected on either side of a single screen. Jackson makes recourse to traditional modes of entertainment in this work, both steeped in myth — the animated picture story and a musical performance with a traditional Chinese stringed instrument, the Erhu.

The binary sets up the labour of art against that of the alienated labour of the workplace. The performance of the woman on the Erhu becomes a utopian counterpoint to the alienated labour experienced by the other Chinese woman who is lured to the city to produce eyelashes for Western markets. The musical performance is presented as a documentary film, while the story of the woman making eyelashes is animation, a form that shifts us into a realm of illusion and fantasy. Yet what it presents us with is the cruel story of the effects of exploitation as the woman endures impossible labour demands to pamper the vanity of Western women. In terms of narration, the animation is filled with archetypal stories; the woman's attraction to the city, the cruel employer, the unrelenting demands of the tedious labour, and the woman's final escape down knotted sheets from her dormitory window. The story about the labour-intensive production of eyelashes with human hair is based on a newspaper article that Jackson read; reality provides the factual basis from which she constructed a mythic story. But the true fairytale ending is presented in a realist form, the filmed document of the Erhu performance. A third element of the installation, on a monitor screen, augments and complicates this pairing, by also showing the musician's painstaking and frustrating process of learning the piece of music from scratch.

The entrancement and seduction of the musical performance and the emotive effect of this instrument point to a very different relation to, and experience of labour. There seems to be an allegory here about art as a rewarding and redemptive form of labour. Jackson's indictment of the exploitation of labour has as its ballast the creative resolution in this refined performance. But it is of course edged with the irony that the Chinese musician has to find this relation as an émigrée from her homeland. She has to leave China to study with an English teacher, and this gives her opportunities she would not get from the equivalent mode of Chinese teaching.

Melanie Jackson, *Made in China*, 2005.

Melanie Jackson, *after The Conjuror*, 1996.

The binary of labour and art that is set up in *Made in China*, 2005 has an interesting precursor in an earlier work, *after The Conjuror* from 1996 where Jackson contrasted a culturally venerated artwork, Bosch's fifteenth-century painting of a conjuror performing a card trick, with filmed footage of Eastern European immigrants playing tricks for tourists. Again, art, in the form of Western painting, provides the utopian counterpoint to more degrading conditions of labour. Jackson has spoken of the work as charting a 'fall from grace'. The entertaining deceptions of these immigrants in Berlin are in order to get money to survive. They have fallen out of the market system and are improvising. The values and relation to the figure of the magician in Bosch's painting contrast with those now associated, in the racist imaginary, with the immigrant, as a people of deception, who are not to be trusted. But by putting the artwork adjacent to this display of labour (for it is a kind of labour) their trickery is given cultural validation. Much as it can be seen to narrate, as Jackson suggests, a fall from grace, it can also be seen to give grace to these labouring entertainers. The relationship set up with Bosch's great artwork challenges the lowly associations of their trade, and the assumptions that might be made about these immigrants.

Alexander Gerdel, *Workshop 69*,1997.

Repair

The work of the Venezuelan artist Alexander Gerdel alerts us to the need to temper the globalising and homogenising claims of commodity culture with the recognition that such conditions of consumption are neither universal nor available to all, but are dependent upon the economic ability to participate.

Gerdel's *Workshop 69*, 1997 alludes to a social reality where the preoccupation with a commodity's 'sign value' could be considered a luxurious indulgence, one that takes second place to the commodity's utilitarian purpose. Originally exhibited in 1997, the year prior to the election of the populist president Hugo Chavez, *Workshop 69* was produced as a site-specific performance for the Alejandro Otero Museum of Contemporary Art in Caracas, Venezuela, and is now viewed in the form of photographs and video documentation. *Workshop 69* highlights a very different relation to labour and commodities from that usually depicted in developed consumer cultures.

Despite possessing one of the largest oil deposits in the world, around 60% of Venezuelan households are officially defined as poor. Since the election of Chavez in 1998, much of the country's oil revenue has been directed to fund popular social programmes, providing free health care, food subsidies and instituting land reform.

Workshop 69 responds to the under-developed nature of Venezuela as a producer of consumer goods and the conditions of economic hardship experienced by many of its citizens during the mid-1990s. As Gerdel states, 'in my country we manufacture very little and only produce raw material, almost everything is imported, so it's very common to request technical repair.'[79] Such a culture of salvage and repair obviously has its counterpart in the thrift culture of North America and the UK, but Gerdel's *Workshop 69* explicitly foregrounds the social relationship between the depleted commodities and the continuance of their *use* value through the presentation of the workers' skilled labour.

For *Workshop 69*, Gerdel created a fictitious electrical repair company similar to one that had operated in the poor district of Caracas where the artist had lived. Two retired technicians were hired and paid to repair household electrical goods in a constructed 'workshop', on view to the public, within the Alejandro Otero Museum. Prior to the commencement of their public repair work, the technicians were asked to inspect electrical goods belonging to the artist's mother. Museum staff carried out video and photographic documentation of items requiring repair, before taking the appliances to Gerdel's *Workshop* at the museum. On the first day of the exhibition, the technicians, dressed in identical yellow overalls, complete with the logo of the fictitious company, began the repair of the appliances.

While *Workshop 69* utilises a presentation of labour similar to that employed by Santiago Sierra, the workers in Gerdel's performance attain a greater level of individual identity.

[79] Alexander Gerdel in email correspondence with the authors, 18 June 2007.

The brute pragmatism of Sierra's power relationship with hired workers contrasts with that established by Gerdel. In *Workshop 69* the specific skill of the men he employs is acknowledged and directed toward the realisation of a socially useful task. Gerdel's workers are not mere abstractions, but individuals who possess specific knowledge, experience and reproduce their social identity through what they do and how they do it. With Sierra we are acutely aware of the power relation at work in the contract between the artist and the hired worker. This domination is emphasised through the futility and unproductive nature of the tasks he pays his workers to perform for us. The inertia of the arm that the labourer is paid to put through the ceiling of a gallery highlights his subjugation and his de-individualisation as a mere 'worker'. In contrast, Gerdel's technicians colonise their workspace with markers of their own identity, displaying distinct patterns of behaviour and what Gerdel refers to as 'the moments of creative leisure of these men, where with already obsolete equipment the workers create their own sculptures ... without any intention of utility. It interests me to recreate the intention of liberation of the worker in his own working atmosphere opening a space to occupy it creatively, personalising his site of work.'[80]

It is clear that Gerdel's *Workshop 69* establishes a different relationship to labour and use-value to that represented in Sierra's work. Similarly, Gerdel's attitude to commodity culture is informed by his experience of living in a country where the excessive accumulation and rapid disposal of commodities is not the norm. Nothing could better illustrate the uneven access to, and experience of, commodity consumption across the globe than a comparison between Gerdel's *Workshop 69* and *Break Down*, 2001 by the British artist Michael Landy.[81] In Gerdel's *Workshop 69* the small-scale repair of commodities undertaken by Venezuelan workers dressed in yellow overalls contrasts starkly with Landy's *Break Down* where British workers dressed in blue overalls undertake the large-scale

Alexander Gerdel, *Workshop 69*, 1997.

[80] Alexander Gerdel in email correspondence with the authors, 18 June 2007.
[81] Michael Landy presented *Break Down* in a former C&A store at Marble Arch, 499–523 Oxford Street, London W1, 10–24 February 2001.
Over the course of fourteen days the artist employed a team of operatives to systematically destroy all of his possessions.

destruction of commodities all owned by the artist. *Break Down* presents the drama of an individual's symbolic rejection of consumerism. It is a grand gesture, but as the title of the work suggests, it could also be read as a sign of mental collapse. The fact that the continued accumulation of commodities is considered the norm, from which Landy has spectacularly and knowingly deviated, indicates just how successful the ideology of consumerism has become. *Break Down* highlights the relatively privileged position from which Landy's gesture is made, its sheer scale speaks of a commodity rich culture blessed with the luxury of surplus. Ironically, rather than interpreting the performance as a critique of commodity culture, *Break Down* could be read as a spectacular condensation of consumerism's justifying logic, with Landy performing, in extremis, a process that requires the acquisition of commodities to be quickly followed by indifference and disposal, thereby creating the conditions for new consumption.

Gerdel's *Workshop 69*, with its repair of worn-out appliances owned by the artist's mother, speaks of a different relationship to commodities, one determined by its Venezuelan context. Though less spectacular than Landy's *Break Down*, the work re-establishes the connection between use value, commodities and the human labour that produce them.

Alexander Gerdel, *Workshop 69*, 1997.

143

Conclusion

Variable Capital's discussion of recent and contemporary art that is critically engaged with the effects of commodity culture has pivoted around two approaches: on one hand art that seeks to reveal and disclose the material costs and consequences underlying consumerism, and on the other, a fascination with the surface allure of marketing and commodities.

Zygmunt Bauman in his recent book, *Consuming Life*, characterises what he refers to as the 'consumerist syndrome' as being 'all about speed, excess and waste'.[82] In the hierarchy of recognised values, consumerism has degraded duration and elevated transience. It holds novelty as more valuable and degrades anything that is long lasting. Brian Ulrich's photographs become significant in this respect in showing us commodities bereft of the allure and packaging of the new. So do Richard Hughes' simulated waste objects replete with jokes and allusions to particular social situations and human behaviour. Ulrich's

objects are often on display, but shelved and lit in the rather dusty and grubby spaces of thrift stores they remain sad still lifes. Hughes in contrast animates obsolete and dated commodities; they become enriched by mnemonic triggers and associations. He is a poet of the gutter and waste-ground. Alexander Gerdel's display of the repair work of domestic appliances in Caracas also takes on particular symbolic importance in relation to a consumer culture marked by the planned obsolescence of commodities. Here we confront a different economy and relation to objects. In this respect, Gerdel highlights a relation to domestic objects that can be seen as the very antithesis of Jeff Koons's display of unused Hoovers in New York, with which we began this book.

The consumerist desire not only goes forever unfulfilled but also is constantly restimulated by ever 'new' brands and products. Commodities that were once objects of desire quickly lose their allure.

The consequences of this fast turnaround of commodities are abundantly evident in the art discussed in this book. Many of the artists are conscious of the way art itself is never outside this process. Art is a commodity, as Louise Lawler's photographs so aptly demonstrate. But as a commodity it is nevertheless singled out as a special commodity and a very expensive one. Much of the art Lawler photographs is now recognisable, authored, and canonical. For all the jokes at the expense of Modernist autonomy, Lawler's art still seems to speak of a surplus, of something beyond the context in which she shows it. She trades on the kudos of the art she reframes. In some sense her art plays a game with art history: she reshuffles the cards to show us the operations and investments underlying particular artworks. She might even be seen as a rogue curator, sabotaging traditional connoisseurship, playing with the value systems and hierarchies underpinning our engagements with art. Art is never seen in a void, but in

particular social and material contexts. The art on the auction house walls she photographs might come with a price tag, but even before such photographs one senses that this monetary reduction of the artwork is ultimately insufficient. Art might not speak of values that can fully transcend its particular economic contexts, but it opens up spaces in which one can nevertheless think beyond the constraints and limits of the consumerist syndrome.

The quality of endurance and non-obsolescence is arguably integral to most artistic aspirations. Art has often set itself apart from the low-grade cheap and quick thrills of commodity culture. The sense of art as counterpoint to consumer culture was seriously challenged by Pop art. The romantic model of a responsive and affective artist was replaced by Andy Warhol with his embrace of indifference and 'surface', a stance extended in Koons' relation to the dumb commodity. It seems telling that Koons should choose objects associated with

[82] Zygmunt Bauman, *Consuming Life*, Cambridge: Polity Press, 2007, p. 86.

cleaning. His 'Hoovers' can be shown as being unused products, illuminated by fluorescent lights that both fetishise and show up these objects' very lack of use, where there are no traces of dirt. Here is an object frozen and eternalised by art. The display case shifts us from the shop window to the museum — fixed in the past, the products become dated and accrue a different value as the artwork endures, now notable and identifiable by the name of the artist, Koons.

The same is true of Richard Prince's work. The advertisements he rephotographs now look dated and mannered; they speak of a particular period and a whole host of values, different to those of the present. Neither artist can freeze out history. The inculcated restlessness of consumerist desire aids in their works' ultimate distinction, the very familiarity of the objects and images they use are soon made unfamiliar by obsolescence.

Koons and Prince exemplify a fascination with commodity appeal. The aura of art associated with timeless values felt to be intrinsic in the artwork is replaced by the short-lived commercial promotional aura of the commodity, and the aura of the artist as star. Warhol's interrogation of the culture industry's production and manufacture of stardom and fame is coupled with a canny ability at self-promotion and marketing. The point of his art was driven by his desire to be the central star. Yet the richness of works like *Screen Tests* is precisely its dis-assembly of the mechanics of the celebrity and star-driven commercial film industry. It is in this context we should also view Larry Sultan's absorbing studies of the porn industry and Philip-Lorca diCorcia's *Hollywood*. The glowing light that bathes the drifters and prostitutes, paid to pose and perform to camera in diCorcia's staged tableaux, symbolises the dream and fantasy of Hollywood. With Sultan the glamour of the porn star is undercut by looks of vulnerability, uncertainty and boredom to his camera, and the correlations set up between the sex workers and the objects that litter the spaces.

Hans Op de Beeck's use of mechanised devices — escalators, treadmills, the rotating podium of the peep show — finds its corollary in the very medium and format used for the display of his art: the endlessness of the video film loop. Such art establishes a succinct metaphor for the infinite circuits of desire that characterise the consumerist act as one of perpetual deferral. Op de Beeck shows us human subjects succumbing to a system that they cannot quite fit, the family on a treadmill struggling to keep going. The system to which they have to adapt is going too quickly for them. Julian Rosefeldt's *Global Soap* and *News* also trade on the systematic and standardised demands of consumer culture. His sampling of the modes of presentation and performance in worldwide news broadcasts and TV family sagas highlights a frightening homogeneity. News and entertainment conform to generic conventions and models. There is little space for signs of local difference and resistance as the face of the culture industry is one of blanket uniformity.

Many of the artists discussed in *Variable Capital* speak from inside the global culture industry. Their art functions as critique by warping or distorting its mechanics. Documentary photography still carries with it the idea of disclosure and revelation and something of this older traditional notion underlies the work of Edward Burtynsky. The destructive effects of global capitalism are shown in his spectacular documents of waste recycling in China. In some sense his art is one of simply evidencing disasters, but at the same time Burtynsky's work reveals some of the limits and problems central to the photographic medium. His pictures return us to an issue Walter Benjamin raised in the 1930s, that the medium can make everything beautiful and in so doing help commodify poverty. Burtynsky's recycling pictures in this respect could be said to entail their own process of recycling, as places in China polluted and choking with the

effects of the West's consumerist binge are returned to the West in the form of contemporary sublime landscapes. Wang Qingsong's photographs from China offer another facet of capital effects, constructing and staging scenes — in a perverse echo of Hollywood glamour — that narrate his country's rapid transformation by its embrace of consumerism. Qingsong's pictures define a different point of excess from Burtynsky's, as signs from China's Communist past are mixed with the gaudy show of capitalist culture. His own narcissistic centrality in the work, much as it might be seen as a desperate desire to belong to the star-struck Western art world, might also be seen as an astute parody of the shallowness and superficiality of the current market-centred and fashion-driven contemporary art scene. For the British artist, Melanie Jackson, China becomes the location from which she draws out two different stories — one of exploitation and the other redemption. The labour of art, in the form of a Chinese

woman's training and study to play a traditional Chinese musical instrument, offers a utopian counterpoint to her animation about the hellish labour conditions in a Chinese factory that produces fake eyelashes for the Western markets. But that the musician has to train in London not China complicates the simple opposition Jackson's work initially seems to set up.

Common Culture's Brechtian art disrupts the familiar transactions underlying the experience of aspects of popular British culture. Theirs is a particularly urban art, fixated with its tawdry spectacles, from the glut of gaudy fast food displays to the waste and excess of over-consumption in the sated bodies of *Binge*. In their *Pop Trauma* videos, photographs and performances they isolate the acts of nightclub entertainers and workers, turning their labour into spectacles — where pleasure and consumption on the part of the viewer is disrupted by moments of social awkwardness and embarrassment.

The art of both Santiago Sierra and Boris Mikhailov openly shows the manipulative effects of money. Their art offers a distinct challenge to the idea of art as non-exploitational. Mikhailov's photographs function within a specific geographic context and have a certain documentary specificity and fixity, reflecting upon the particular vulnerability of the new poor in the post-Communist state of the Ukraine. According to Mikhailov the homeless people he pictures are to be seen and understood as an effect of capitalism. They did not exist under Communism. In contrast, Sierra's performances are played out on the global stage of contemporary art, using people vulnerable to manipulation and exploitation — illegal immigrants, prostitutes, drug addicts, the poor — people whose labour is cheap. This is what makes his art so uncomfortable. His work is about power: the ease with which the labour power of sellers can be bought by the economic power of buyers. Sierra often puts on display humiliating

and degrading acts of labour. Work becomes linked with endurance and punishment, since the tasks are often menial and futile. Sierra pays the wage and his labourers do what he says. The profit and excess of this exchange in effect becomes the artwork, which as a commodity is subject to its own packaging, promotion, marketing, and price. He makes visible the unpleasant costs of art's very internationality. Art is not the utopian and transcendental site it is often fantasised to be.

Everything has its price.

Photography Credits

Bickerton, Ashley
Good Painting, 1988. (p. 16)
Mixed media construction with neoprene
covering, 90 x 69 x 18 inches
(229 x 175 x 46 cm) AB-25
Courtesy Sonnabend Gallery

*Abstract Painting for People #4
(Bad)*, 1987. (p. 19)
Aluminum paint, acrylic on polymer resin
and plywood with anodised aluminium,
68 x 48 x 15 inches
(173 x 122 x 38 cm) AB-11
Courtesy Sonnabend Gallery

*Tormented Self-Portrait
(Susie at Arles)*, 1988. (p. 24)
Mixed media construction with
black padded leather,
90 x 69 x 18 inches
(229 x 175 x 46 cm) AB-32
Courtesy Sonnabend Gallery

Burtynsky, Edward
*China Recycling # 8, Plastic Toy Parts, Guiyu,
Guangdong Province, China*, 2004. (p. 130)
39 x 49 inches
Courtesy of Flowers, London

*China Recycling # 9, Circuit Boards, Guiyu,
Guangdong Province, China*, 2004. (p. 133)
39 x 49 inches
Courtesy of Flowers, London

*China Recycling #12, Ewaste Sorting,
Zeguo, Zhejiang Province, China*, 2004. (p. 132)
27 x 34 inches
Courtesy of Flowers, London

*China Recycling #24, Cankun Aluminium,
Xiamen City, Fujian Province, China*, 2005.
(p. 134, p. 135)
40 x 60 inches
Courtesy of Flowers, London

Common Culture
Colour Menus Installation, 2002,
*Shopping – A Century of Art and Consumer
Culture. The Tate Gallery, Liverpool.*
(p. 8, p. 52, p. 63)
© Common Culture

Local Comics, 2005. (p. 50, p. 56, p. 57)
© Common Culture

Bouncers, 2005. (p. 58, p. 59)
© Common Culture

Binge, 2007. (p. 96)
© Common Culture

diCorcia, Philip-Lorca
*Eddie Anderson; 21 years old;
Houston, Texas; $20*, 1990-92. (p. 94, p. 95)
(desc. PL.010)
© Philip-Lorca diCorcia
Courtesy of the artist and Pace/MacGill
Gallery, New York

*Ralph Smith; 21 years old;
Ft. Lauderdale, Florida; $25*, 1990-92. (p. 92)
(desc. PL.040)
© Philip-Lorca diCorcia
Courtesy of the artist and Pace/MacGill
Gallery, New York

Gerdel, Alexander
Workshop 69, 1997. (p. 140, p. 142, p. 143)
© Alexander Gerdel
Courtesy of the artist

Graham, Paul
*Mother and Baby, Highgate DHSS,
North London*, 1984. (p. 34, p. 35)
© Paul Graham
Courtesy of Anthony Reynolds Gallery, London

Gursky, Andreas
Ohne Titel IV (Prada I), 1996. (p. 109)
C-Print, 154 x 321 x 6.2 cm (framed)
© Andreas Gursky / VG Bild-Kunst
Courtesy of Monika Sprüth / Philomene
Magers, Cologne Munich London

Ohne Titel VI , (Pollock), 1997. (p. 113)
C-Print, 185.5 x 442.6 x 6.2 cm (framed)
© Andreas Gursky / VG Bild-Kunst
Courtesy of Monika Sprüth / Philomene
Magers, Cologne Munich London

99 Cent, 1999. (p. 113, p. 111)
C-Print, 207 x 336.9 x 6.2 cm (framed)
© Andreas Gursky / VG Bild-Kunst
Courtesy of Monika Sprüth / Philomene
Magers, Cologne Munich London

Halley, Peter
Prison with Yellow Background, 1984. (p. 20)
60 x 60 inches, acrylic, Day-Glo acrylic,
and Roll-a-Tex on canvas.
Courtesy of the artist

Blue Cell with Triple Conduit, 1986. (p. 23)
77 x 77 inches, acrylic, Day-Glo acrylic,
and Roll-a-Tex on canvas.
Courtesy of the artist

Hughes, Richard
Untitled (match), 2003. (p. 103)
Mixed media, 61.5 x 21.5 x 15.5 cm,
24.2 x 8.5 x 6.1 inches, 2 of 5,
TMI-HUGHR-00021
Courtesy of the artist and The Modern
Institute/Toby Webster Ltd, Glasgow

After the Summer of Like, 2005. (p. 100)
Re-upholstered sofa, hand-dyed canvas, wire
modelling putty, spray paint, enamel paint,
82 x 204 x 89 cm, 32.3 x 80.3 x 35 inches,
TMI-HUGHR-00038
Speyer Family Collection

Roadsider (First of the Morning), 2005. (p. 102)
Resin, 30.5 x 8 x 8 cm, 12 x 3.1 x 3.1 inches,
TMI-HUGHR-00032
Private Collection

Jaar, Alfredo
Rushes, 1986. (p. 30)
Installation of 81 photographs, public
intervention at the New York City subway
at Spring Street and Sixth Avenue
Copyright Alfredo Jaar
Courtesy of Galerie Lelong, New York

Kelley, Mike
Untitled (3 octopi), 1990. (p. 98)
Afghans, dolls, 49.5 x 19.75 x 19.75 inches
Photograph by Douglas Parker
Courtesy of the Artist and Metro Pictures,
New York

Koons, Jeff
Nelson Automatic Cooker/Deep Fryer, 1979.
(p. 12)
Appliance, acrylic, fluorescent lights,
27 x 17 x 16 inches
© Jeff Koons

*New Hoover Deluxe Shampoo Polishers, New
Shelton Wet/Dry 5-Gallon Displaced Quadra
Decker*, 1981-1987. (p. 11)
Vacuum cleaners, Plexiglas, fluorescent lights,
116 x 54 x 28 inches
© Jeff Koons

*Equilibrium, Installation, International with
Monument Gallery, New York*, 1985.
(p. 14, p. 15)
© Jeff Koons

Lawler, Louise
Pollock and Tureen, 1984. (p. 118)
Cibachrome (image), 16 x 20 inches
Courtesy of the Artist and Metro Pictures

Monogram, 1984. (p. 121)
Cibachrome (image), 39 1/2 x 28 inches
Courtesy of the Artist and Metro Pictures

Does Marilyn Monroe Make You Cry? 1988.
(p. 117)
Cibachrome, Plexi Wall label (image)
27 1/4 x 39 inches
Courtesy of the Artist and Metro Pictures

Does Andy Warhol Make You Cry? 1988.
(p. 116)
Cibachrome, Plexi Wall label (image)
27 1/4 x 39 inches
Courtesy of the Artist and Metro Pictures

Board of Directors, 1988/1989. (p. 120)
Black and white photograph with printed mat,
16 x 22 1/4 inches (image),
28 x 32 1/4 inches (mat)
Courtesy of the Artist and Metro Pictures

(Bunny) Sculpture and Painting, 1999. (p. 4)
Cibachrome (museum mounted),
47 1/2 x 66 inches
Courtesy of the Artist and Metro Pictures

White Gloves, 2002/2004. (p. 114)
Cibachrome laminated on aluminum
museum box,
29 x 27 1/4 inches
Courtesy of the Artist and Metro Pictures

Closer than You Thought, 2004/2005. (p. 10)
Cibachrome on aluminum box, laminated,
41 x 32 1/2 inches
Courtesy of the Artist and Metro Pictures

Jackson, Melanie
Made In China, 2005 (detail) (p. 136)
Courtesy of the artist and
Matt's Gallery, London

Made In China, 2005 (animation still) (p. 137)
Courtesy of the artist and
Matt's Gallery, London

after The Conjuror, 1996. (p. 138, p. 139)
Project Arts Centre, Dublin
Courtesy of the artist and
Matt's Gallery, London

Mikhailov, Boris
From "Case History" series, 1999.
(p. 36, p. 39)
© Boris Mikhailov
Courtesy of Pace/MacGill Gallery, New York

Op de Beeck, Hans
Determination (1), 1996. (p. 66)
Video, colour, silent (2 minutes,
35 seconds; looped)
Courtesy: Xavier Hufkens, Brussels,
Galleria Continua, San Gimignano - Beijing
and Galerie Krinzinger, Vienna

Sub-, 1997. (p. 70)
Video, colour, silent (1 minute; looped)
Courtesy: Xavier Hufkens, Brussels,
Galleria Continua, San Gimignano - Beijing
and Galerie Krinzinger, Vienna

Determination (4), 1998. (p. 73)
Video, colour, silent (7 minutes,
45 seconds; looped)
Courtesy: Xavier Hufkens, Brussels,
Galleria Continua, San Gimignano - Beijing
and Galerie Krinzinger, Vienna

Insert Coin for Love, 1999. (p. 71)
Video, colour, sound (3 minutes, 9 seconds)
Courtesy: Xavier Hufkens, Brussels,
Galleria Continua, San Gimignano - Beijing
and Galerie Krinzinger, Vienna

Situation (1), 2000. (p. 68, p. 69)
Video, colour, silent (1 minute,
31 seconds; looped)
Courtesy: Xavier Hufkens, Brussels,
Galleria Continua, San Gimignano - Beijing
and Galerie Krinzinger, Vienna

Parr, Martin
New Brighton, 1985. (p. 32)
Image: LON6979, G.B. ENGLAND.
Courtesy of Martin Parr/MagnumPhotos

Tokyo, Disneyland, 1998. (p. 32)
Image: LON12588, JAPAN.
Courtesy of Martin Parr/MagnumPhotos

Prince, Richard
Untitled (Girlfriend), 1993. (p. 44)
Ektacolor photograph, 44 x 64 inches,
(111.8 x 162.6 cm)
Edition of 2 + 1 AP RP762
© Richard Prince
Courtesy Gladstone Gallery, New York

One on One, 2005-06. (p. 48)
Fibreglass, bondo, acrylic and wood.
52 1/4x 53 7/8x 9 1/2 inches
132.7 x 136.8 x 24.1 cm RP2081
© Richard Prince
Courtesy Gladstone Gallery, New York
Signed, dated and titled on verso

Untitled (cowboy), 1980-89. (p. 46, p. 47)
Ektacolor photograph
72 x 108 inches
182.9 x 274.3 cm
© Richard Prince
Courtesy Gladstone Gallery, New York

The Wrong Joke, 1989. (p. 49)
Acrylic and silkscreen on canvas
56 x 48 inches
142.2 x 121.9 cm
© Richard Prince
Courtesy Gladstone Gallery, New York

Qingsong, Wang
Vagabond, 2004. (p. 122)
Courtesy of the artist and
Albion Gallery, London

Competition, 2004. (p. 128, p. 129)
Courtesy of the artist and
Albion Gallery, London

Billboard, 2004. (p. 126, p. 127)
Courtesy of the artist and
Albion Gallery, London

Home, 2005. (p. 124, p. 125)
Courtesy of the artist
and Albion Gallery, London

Rosefeldt, Julian
News, 1998. (p. 074)
2-channel video, 16 channel
audio installation, loop 90 min
Julian Rosefeldt and Piero Steinle
Courtesy of the artist
and Max Wigram Gallery, London

Global Soap. (p. 76, p. 77)
Courtesy of the artist
and Max Wigram Gallery, London

Sierra, Santiago
*Space Closed off by Corrugated Metal
Lisson Gallery. London, United Kingdom.
September 2002*. (p. 84)
Courtesy of the artist
and Lisson Gallery, London

*Obstruction of a Freeway with a Truck's Trailer
Anillo Periférico Sur. Mexico City, Mexico.
November 1998*. (p. 85)
Courtesy of the artist
and Lisson Gallery, London

*A Worker's Arm Passing Through the Ceiling
of an Art Space from a Dwelling
Calle Orizaba, 160. Mexico City, Mexico.
January 2004*. (p. 82)
Courtesy of the artist
and Lisson Gallery, London

*Workers Who Cannot be Paid, Remunerated to
Remain Inside Cardboard Boxes
Kunst Werke. Berlin, Germany. September
2000*. (p. 80)
Courtesy of the artist
and Lisson Gallery, London

*Line of 30cm Tattooed on a
Remunerated Person
51 Regina Street. Mexico City, Mexico.
May 1998*. (p. 78)
Courtesy of the artist
and Lisson Gallery, London

*Object Measuring 600 x 57 x 52 cm
Constructed to be Held Horizontally
to a Wall*, 2002.
(p. 144)
Courtesy of the artist
and Lisson Gallery, London

Steinbach, Haim
Supremely Black, 1985. (p. 26)
Mixed media construction,
29 x 66 x 13 inches
(74 x 168 x 33 cm) HS-11
Courtesy Sonnabend Gallery

Ultra-red 2, 1986. (p. 29)
Mixed media construction,
63 x 76 x 19 inches
(161 x 193 x 48 cm) HS-17
Courtesy Sonnabend Gallery

Sultan, Larry
Hamner Drive, 2002. (p. 88)
Courtesy of Galerie Thomas Zander, Cologne

Backyard, Film Set, 2002. (p. 89)
Courtesy of Galerie Thomas Zander, Cologne

Kitchen Floor, Reseda, 2000. (p. 86)
Courtesy of Galerie Thomas Zander, Cologne

Den, Santa Clarita, 2002. (p.90)
Courtesy Alexandre Pollazzon Ltd. London

Sharon Wild, 2001. (p. 91)
Courtesy Brancolini Grimaldi
Artecontemporanea, Rome

Ulrich, Brian
Madison, WI 2005, (Hangers), 2005. (p. 108)
Edition of 4, 40 x 50 inches;
Edition of 6, 30 x 40 inches
C-print
Courtesy of the artist and Rhona Hoffman
Gallery, Chicago

Untitled Thrift, 2006, *(Aisle)*, 2006. (p. 105)
30 x 40 inches
Edition of 9
C-print
Courtesy of the artist and Rhona Hoffman
Gallery, Chicago

Untitled Thrift, 2006, *(Vhs)*, 2006. (p. 106)
30 x 40 inches
Edition of 9
C-print
Courtesy of the artist and Rhona Hoffman
Gallery, Chicago

Untitled Thrift, 2006, *(Britney)*, 2006. (p. 112)
30 x 40 inches
Edition of 9
C-print
Courtesy of the artist and Rhona Hoffman
Gallery, Chicago

Untitled Thrift, 2006 (Shoe Pile), 2006. (p. 104)
Edition of 5, 48 x 60 inches;
Edition of 9, 30 x 40 inches
C-print
Courtesy of the artist and Rhona Hoffman
Gallery, Chicago

Chicago IL 2005 (Toys), 2005. (p. 104, p. 107)
Edition of 6, 30 x 40 inches;
Edition of 4, 40 x 50 inches
C-print
Courtesy of the artist and Rhona Hoffman
Gallery, Chicago

Wall, Jeff
Bad Goods, 1985. (p. 40)
Azo dye transparency and light box,
65 x 250 x 30 cm
Collection of the Vancouver Art Gallery,
Vancouver Art Gallery Acquisition Fund VAG
85.89 a-g

Warhol, Andy
Screen Test: Ann Buchanan, 1964. (p. 65)
16mm film, black & white, silent,
4 minutes at 16 frames per second
© 2007 The Andy Warhol Museum, Pittsburgh,
PA, a museum of Carnegie Institute.
All rights reserved.
Film still courtesy of The Andy Warhol Museum

Screen Test: Marcel Duchamp, 1966. (p. 62)
16mm film, black & white, silent,
4 minutes at 16 frames per second
©2007 The Andy Warhol Museum, Pittsburgh,
PA, a museum of Carnegie Institute.
All rights reserved.
Film still courtesy of The Andy Warhol Museum

Screen Test: Dennis Hopper, 1964. (p. 60)
16mm film, black & white, silent,
4 minutes at 16 frames per second
©2007 The Andy Warhol Museum, Pittsburgh,
PA, a museum of Carnegie Institute.
All rights reserved.
Film still courtesy of The Andy Warhol Museum

Screen Test: Susan Sontag, 1964. (p. 63)
16mm film, black & white, silent,
4 minutes at 16 frames per second
©2007 The Andy Warhol Museum, Pittsburgh,
PA, a museum of Carnegie Institute.
All rights reserved.
Film still courtesy of The Andy Warhol Museum

Index

First published 2007 by

LIVERPOOL
UNIVERSITY PRESS

Liverpool University Press
4 Cambridge Street
Liverpool
L69 7ZU
www.liverpool-unipress.co.uk

and

the Bluecoat.

the Bluecoat.
School Lane, Liverpool, L1 3BX
Telephone 0151 709 5297
Fax 0151 707 0048
www.thebluecoat.org.uk

Distributed in Canada, Mexico and
the USA by University of Chicago Press
www.press.uchicago.edu

British Library Cataloguing-in-Publication Data
A British Library CIP record is available

ISBN 978-1-84631-126-0

Designed by Lawn Creative, Liverpool

Header text: DIN 48pt
Body text: DIN 9/10pt

Cover: Re-used, post consumer waste,
carton board, each copy unique
Text: 170gsm Silk Art

Printed in the European Union by
The Studio, Manchester